W9-DEW-801

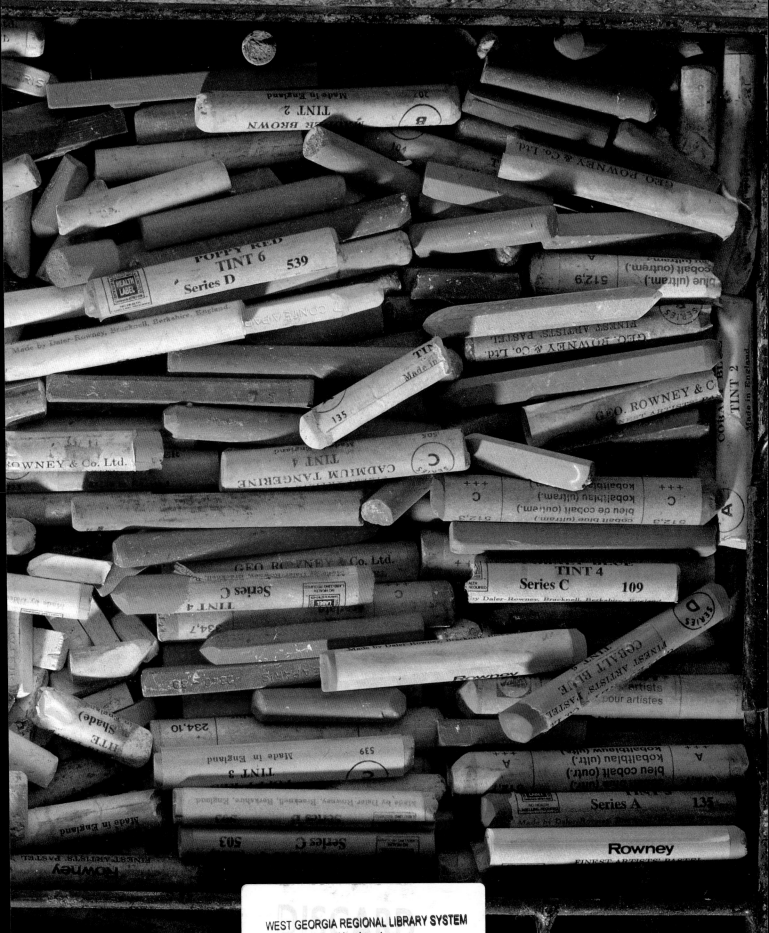

For my parents

STEP BY STEP ART SCHOOL
PASTELS

GERALDINE CHRISTY

CHARTWELL
BOOKS, INC.

For copyright reasons this edition is
for sale only within the USA

This edition published in 1992 by
Chartwell Books, Inc.
A division of Book Sales, Inc.
110 Enterprise Avenue
Secaucus, New Jersey 07094

Prepared by
The Hamlyn Publishing Group
part of Reed International Books Limited
Michelin House, 81 Fulham Road, London SW3 6RB

Copyright © Reed International Books Limited 1992

ISBN 1-5521-759-1

Designed and edited by
Sports Editions Limited
3 Greenlea Park
Prince George's Road
London
SW19 2JD

Produced by Mandarin Offset
Printed in Hong Kong

Contents

Chapter 1
Introduction

Pastels are one of the most versatile of media and offer the artist some major advantages. They can be used for sketching and line drawing, but their true beauty lies in the broad sweeps of colour that can be built up quite rapidly and it is for this reason that they are classified as 'paints'.

From the practical point of view pastels provide a convenient way of painting without too much mess. They are applied dry and do not need to be mixed with water or turpentine. As a result, the colours stay true and you can see the effect you are achieving while you are working. Almost pure pigment is used and so the colours have a vibrant intensity that is actually quite unique.

Pastels are held in the hand and literally allow you to get a 'feel' for the paint by blending the colours with your fingers — the messiest part about using this medium. Since they are dry, they tend to be rather powdery and do not always adhere well to the paper or board, so a light spray of fixative is usually necessary to ensure your painting is protected.

Introduction

HISTORY OF PASTELS

The use of pastels in the form of chalks and crayons dates back to the late 15th century, though only a limited palette of black, white and red was available to the masters of the Italian Renaissance. Leonardo da Vinci introduced red, choosing it for his drawings of horses for the planned Sforza Monument and initial studies for the *Last Supper*. By the early 16th century other artists such as Michelangelo and Raphael were using colour for their line drawings, and Andrea del Sarto proceeded to develop the technique of using areas of colour for shading and form.

It was not until the 18th century, however, that artists could use a full palette of colours and the medium and its techniques could be properly explored. The blending of colours led naturally to the use of pastels as a true painting medium with variety and subtlety of tone. Artists soon found that they were suitable for the portraits which were fashionable at the time, and one of the first to specialize in the genre was Joseph Vivien (1657–1735). A Venetian artist, Rosalba Carriera (1675–1757), contributed greatly to the popularity of pastels by using them extensively in portraiture, and her visit to Paris in 1720 influenced many artists of the day.

One of the most well-known pastel painters was Maurice-Quentin de La Tour (1704–88), who portrayed a remarkable depth of character in his subjects, achieved through a fine technical skill in drawing and a smooth finish to his work. His contemporary, Jean-Baptiste Perroneau (1715–83), delighted in the handling of colour in a rather looser style, and though his portraits lack the insight of La Tour they convey great liveliness and enthusiasm. Chardin (1699–1779), too, painted some portrait masterpieces in pastel, but for the most part he used the medium for sketch studies of the still lifes for which he is renowned.

Some artists, such as the Swiss Jean Etienne Liotard

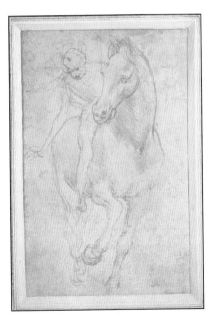

(1702–89), painted landscapes in pastel, though portraiture remained the most popular subject for the medium. English artists such as Francis Cotes (1726–70) and Sir Thomas Lawrence (1769–1830) used pastels in their early work before turning to oils, but gradually as the fashion for portraits declined so artists themselves began to turn away from using pastels.

The artist most responsible for the revival of pastel painting was Edgar Degas (1834–1917), who increasingly chose pastels in the 1870s for his paintings and drawings of ballet dancers. Degas also developed new techniques. He used pastels principally for sketchy line drawing, conveying movement and poise, and freely filling in areas of colour. His style greatly influenced the Impressionists and as his lines became more fluid he superimposed layers of colour, exploring the possibilities of portraying light and form. He experimented with paper, too, soaking it in turpentine to fix the paint and ensure the preservation of his illustrations.

Many of the Impressionists and artists associated with them found pastels an ideal medium for experimentation and for expressing their individual styles. They enjoyed the swiftness of line that pastels could provide and the sheer brilliance of pigment, placing colours side by side, in dappled patches of light and shade, or outlining broad flat areas of colour. Renoir, Gauguin, Toulouse-Lautrec and Matisse all used pastels to great effect.

New mediums are available today, but pastels still continue to be popular. Whatever your style and choice of subject, the work of the artists of the past offers a wealth of inspiration and technical guidance.

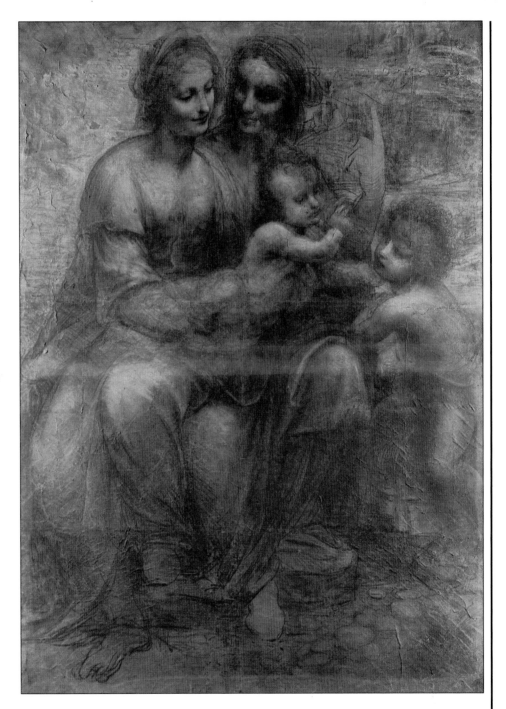

Left Drawing of *Horse and Rider* by Leonardo da Vinci (1452—1519), one of many studies of horses drawn in red chalk.

Right Cartoon for *Virgin and Child with St Anne* by Leonardo da Vinci. A masterpiece drawn with a limited palette.

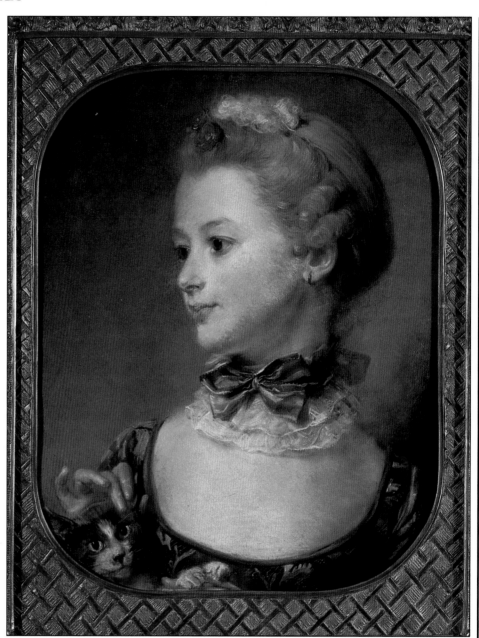

Small girl with a cat, by Jean-Baptiste Perroneau (1715—83). Subtle blending is used to portray delicate skin tones and texture.

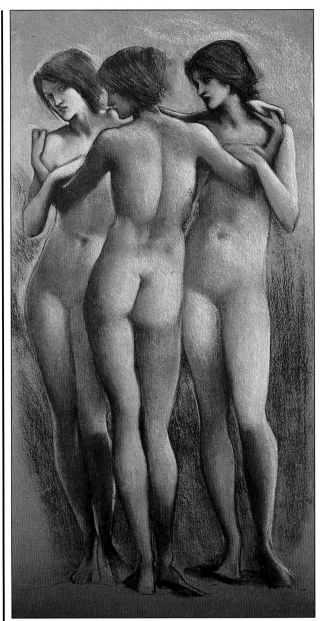

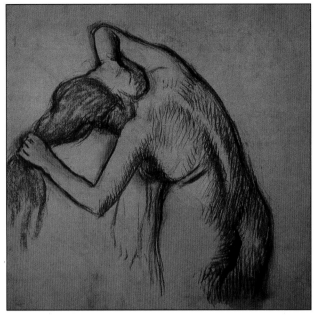

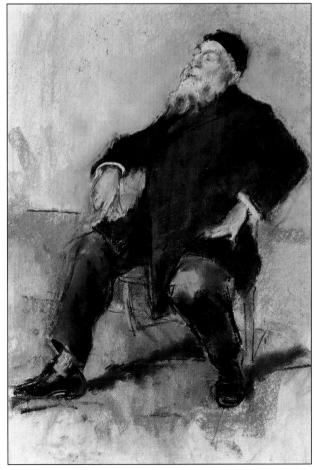

Above In *The Three Graces, c.*1885, by Sir Edward Burne-Jones the colour of the support provides important undercolour.

Above right In this simple line drawing, *Woman Drying Herself,* Degas (1834—1917) uses the technique of hatching to give form.

Right *Rodin, c.*1914, by Henry Tonks. Blended patches of light and shade give shape and character to the figure.

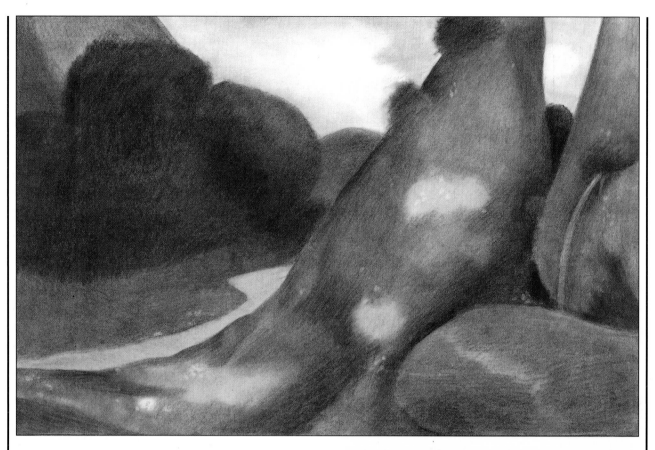

Above *Fantastic Landscape, c.*1905, by Joan Gonzalez. A variety of tones is applied in flowing strokes, combining with perspective to produce an atmospheric landscape.

Right *The Toilet* by Edgar Degas (1834—1917). The softly blended skin texture is enhanced against a looser, layered background. Colours are carefully chosen to emphasize the contrast.

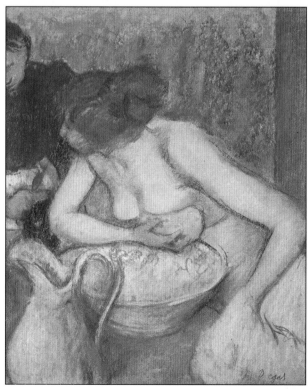

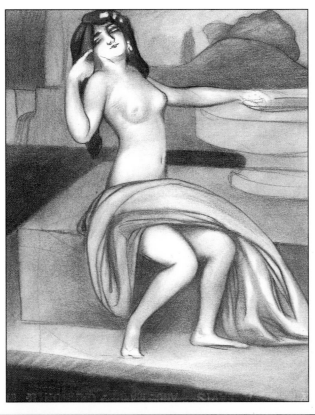

Nude with Drapery,
*c.*1907—8, by Joan
Gonzalez. Gradated
shading gives dimension
and form and is defined
by line.

Stormy Sunset by James
McNeill Whistler
(1834—1903). The use of
blue on the horizon gives
distance and leads the eye
to the bright layers of
colour in the sky.

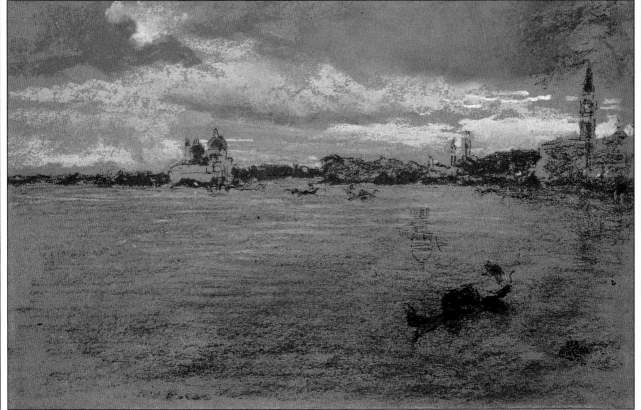

Chapter 2

Equipment

There are so many luscious colours available in pastels that it is tempting to buy more than you really need. If you are choosing soft pastels then a great deal of willpower is required as they come in a huge range of tints, all of which are just waiting to be picked up and tried out. Oil pastels come in brighter colours, but can be equally alluring. Try to assess the range of colours you are likely to use. It is a good idea to buy only two or three initially and use them for sketching or experimenting with before deciding on your final palette.

Do take some trouble over the type of support you use. Papers and boards with a slightly rough texture are the most suitable for pastels as they provide a surface to which the pigment can cling. Even so, you will need to buy some fixative.

A kneadable eraser is useful for removing areas of your painting, as is a twist of paper or torchon, which you can make yourself. If you are intending to specialize in portraits or landscape, then you will find working at an easel much more comfortable.

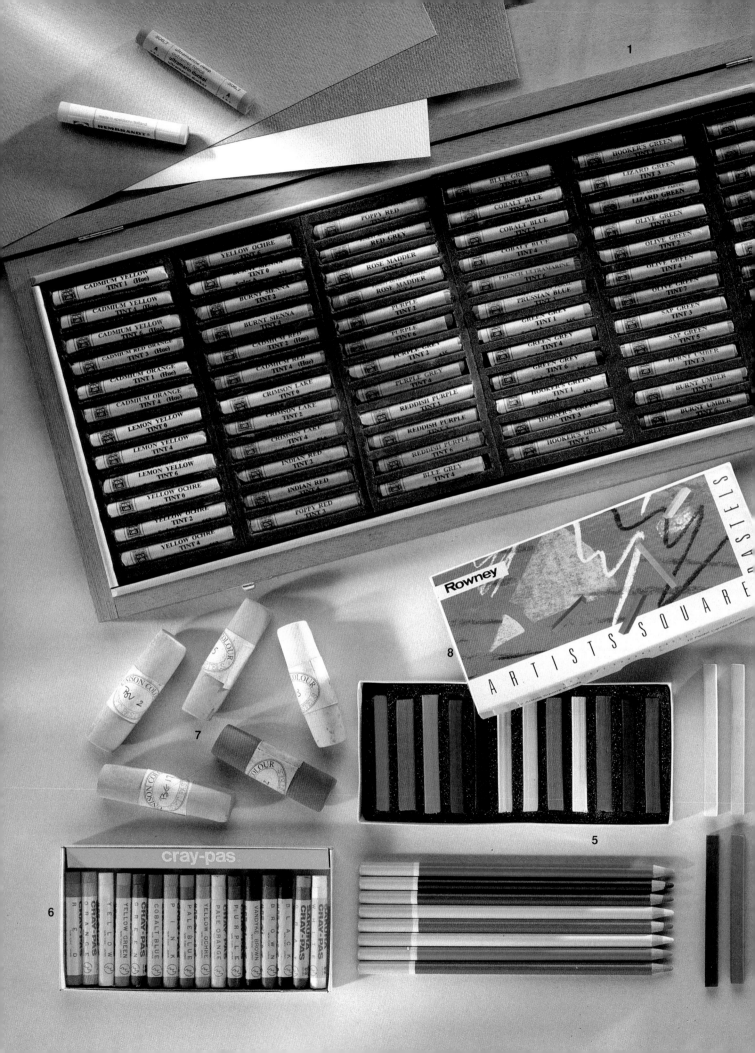

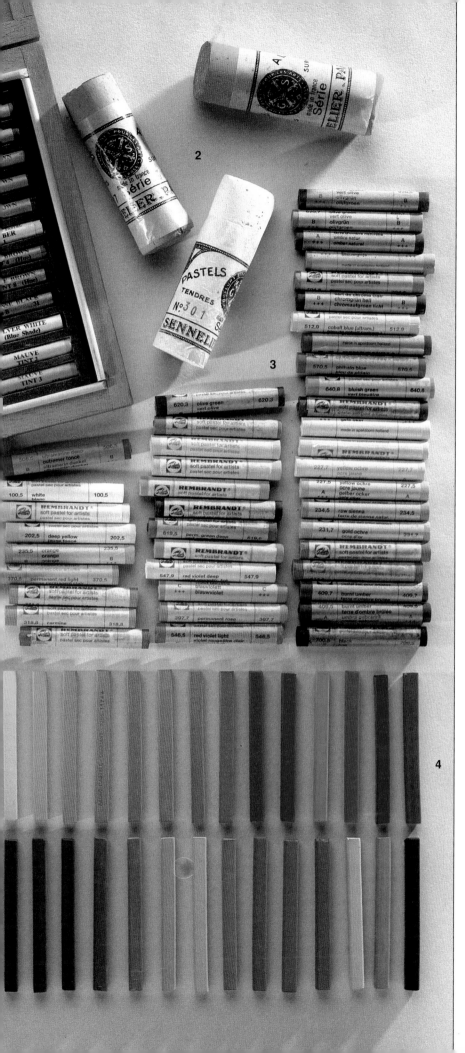

Equipment
PASTELS

Soft pastels

The term 'pastels' is used mainly to describe soft pastels which are sticks or crayons made from powdered pigment bound with gum, and moulded into shape. They come in many thicknesses and lengths, with round or square ends, or in the form of pencils and they are graded soft, medium or hard. With the addition of gum the pigment loses some of its brilliance, so the softest pastels give the brightest colours. A wide range of tints is available in pastels; the paler ones have a white extender added to disperse the pigment and ensure that it covers.

Oil pastels

Oil pastels are available in heavier, brighter colours and do not have the powdery consistency of soft pastels. They are useful for bold work and the colours can be blended with turpentine.

Protecting your pastels

Sticks of soft pastel are powdery so it is essential to store them so that the colours do not rub off onto one another. If you buy them separately make sure that you keep them in a box with card dividers. Pigment is likely to rub off your paintings while you are working on them, but a light spray of fixative will protect them though it may change the colour slightly.

1 Rowney soft pastels
2 Sennelier soft pastels
3 Talens Rembrandt soft pastels
4 Faber-Castell Polychromous soft pastels
5 Stabilo pastel pencils
6 Cray-Pas Oil pastels
7 Unison soft pastels
8 Rowney square pastels

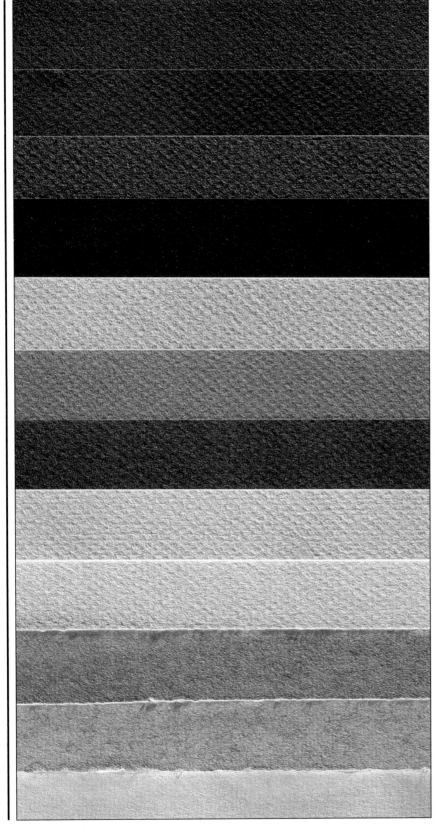

Pastels are applied dry to their support and this means that whether you choose papers or board, you need to select a surface that is quite rough or has some 'tooth' to it. A rough surface will give some texture to which the pigment can adhere. If you use pastel on a coated or shiny paper the pigment will simply fall off as powder.

Traditionally pastel is applied to rather fibrous papers such as Ingres or Canson. These papers are available in a wide variety of colours and tones. Many are in subtle tones that are particularly suited to the delicate effects of pastel work and some have specific attractive features such as flecks. A number of these papers and boards are shown on these pages and you can see just how much variety there is. When you are selecting a paper you should try to bear in mind the range of pastel colours you will be using so that you can make the most of its background tone.

As well as sheets for final work, sketch pads are also available in these types of paper, and come in a wide range of assorted colours.

A surface which is sometimes used by artists who particularly like to work with bold, bright colours is sandpaper or glasspaper. This provides the artist with a strong 'toothed' surface as well as a warm, neutral background colour.

Above A selection of nine Canson papers.
Below A selection of three Tumba Ingres papers.

Stretching paper

Although you are working with dry pigment you will still be applying a wet fixative, and in order to prevent the paper distorting or cockling it is advisable to stretch it beforehand.

This is a very easy process. Simply dip the paper into a bath or basin of water, then lift it out and push the excess water away with a rule or just allow it to drain off. Place the paper on a piece of hardboard and firmly gum down the four sides along the edges. Make sure you use gumstrip. Masking tape or any other sticky tape will tear the paper. When the paper is dry remove the tape, and it is ready for use.

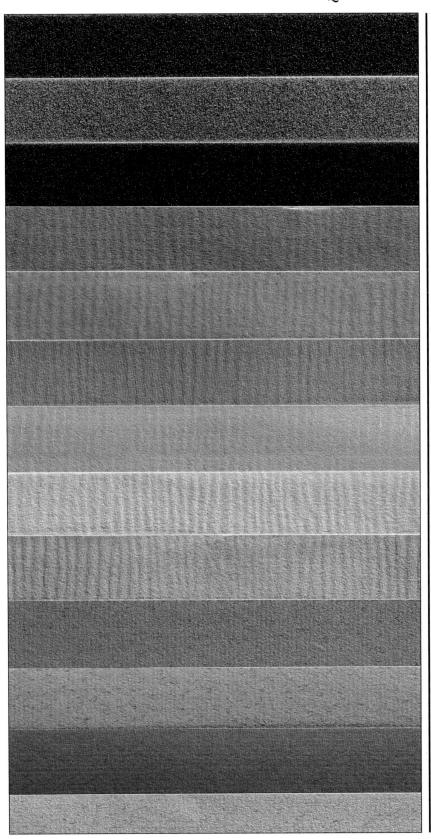

Above A selection of three Sans Fix pastel boards.
Centre A selection of six Old Dutch Ingres papers.
Below A selection of four Tre-Kronor papers.

MATERIALS

1 Bottle of fixative for use with a diffuser. Used for protecting the surface of the painting.

2 Goat hair brush. Used for blending and removing areas of pastel.

3 Aerosol can of fixative.

4 Sketch pads and paper.

5 Large brush used for blending and removing pastel over large areas such as backgrounds.

6 Diffuser for bottle of fixative.

7 Eraser for removing and blending pastel.

8 Kneadable or putty eraser. Can be moulded to a point for removing detailed areas of pastel.

9 Gumstrip for stretching paper.

10 Small torchon. Used for blending pastels in detailed areas. This can also be made from a twist of paper.

11 Graphite stick. This is useful for sketching and for mixing with pastel to give a slightly shiny texture.

12 Torchon. Used for blending. This can be made from a twist of paper.

13 Scalpel. Used for sgraffito techniques, also for sharpening the end of a pastel for detailed work such as lettering where a point is required.

14 Paintbrush. Used for removing small areas of pastel or for blending.

15 Graphite pencil for sketching and adding fine detail and texture to pastels.

16 Bulldog clips for hanging up paper when spraying with fixative.

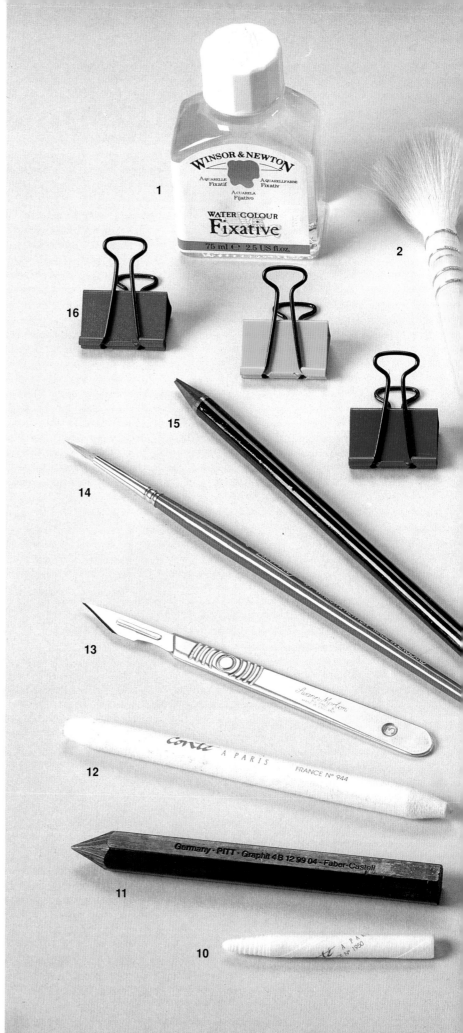

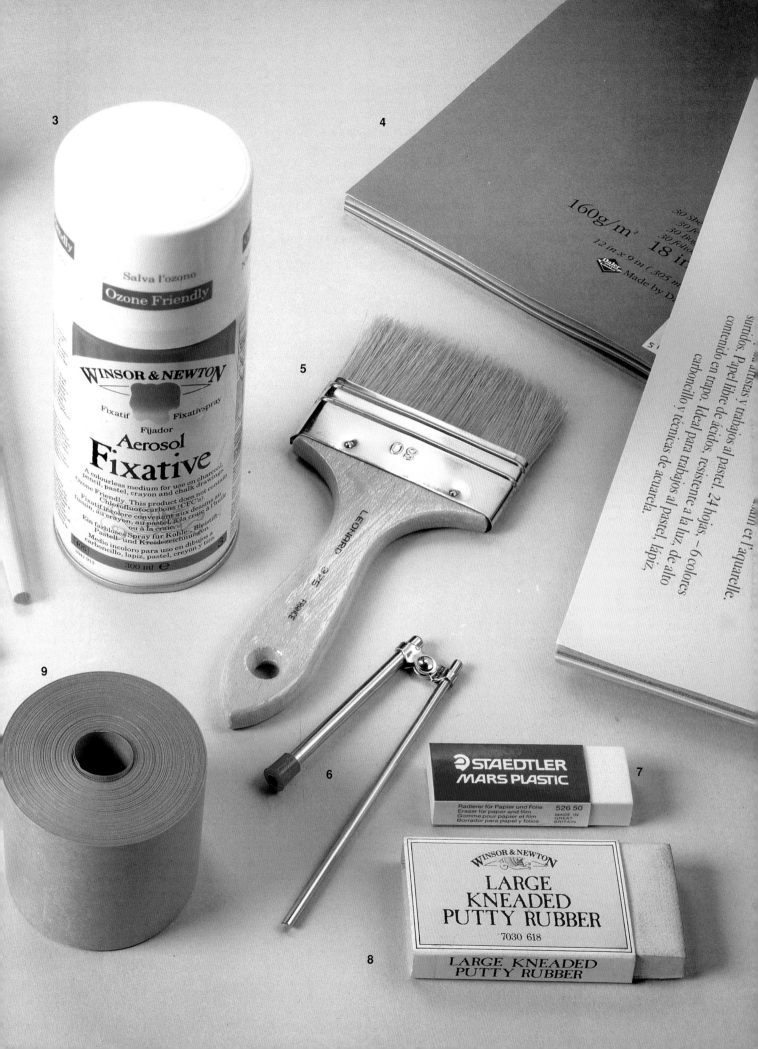

3

Salva l'ozono

Ozone Friendly

WINSOR & NEWTON

Fixatif — Fixativspray

Fijador

Aerosol

Fixative

A colourless medium for use on charcoal, pencil, pastel, crayon and chalk drawings. Ozone Friendly. This product does not contain Chlorofluorocarbons (CFC's).
Fixatif incolore convenant aux dessins au fusain, au crayon, au pastel, à la craie à l'huile ou à la craie.
Ein farbloses Spray für Kohle-, Bleistift-, pastell- und Kreidezeichnungen.
Medio incoloro para uso en dibujos a carboncillo, lapiz, pastel, creyón y tiza.

300 ml e

4

160g/m² 18 in

12 in x 9 in (305 m

Made by D

surtidos. Papel libre de ácidos al pastel, contenido en trapo. 24 hojas.
carboncillo y técnicas de acuarela. 6 colores de alto al pastel, lapiz,

sain et l'aquarelle.

5

80

LEO-HARD

526 FRANCE

9

6

STAEDTLER
MARS PLASTIC

7

Radierer für Papier und Folie 526 50
Eraser for paper and film MADE IN
Gomme pour papier et film GREAT
Borrador para papel y folios BRITAIN

WINSOR & NEWTON

LARGE
KNEADED
PUTTY RUBBER

7030 618

8

**LARGE KNEADED
PUTTY RUBBER**

Chapter 3
Drawing techniques

The key to successful painting often lies in getting your drawing right, and to do this accurately you really need to observe your subject and to be able to translate what you see on to paper. In real life everything has form and shape. When you draw you are creating an illusion of what exists in reality, by trying to reproduce the form and shape of your subject. The established guidelines of perspective provide a framework around which you can build form and shape through line and colour.

This chapter outlines the basic principles of perspective, but practical experience will help you approach your drawing with logic and confidence. A useful method of testing and learning the basic theories of perspective is to trace over photographs or pictures in magazines, working out the vanishing points and areas of light and shade.

The best way to develop your drawing skills is to practise them. Try to sketch wherever you can and carry a small sketchbook with you so you can recall drawings in the future. The human figure provides one of the most complex subjects of all, and one of the most interesting.

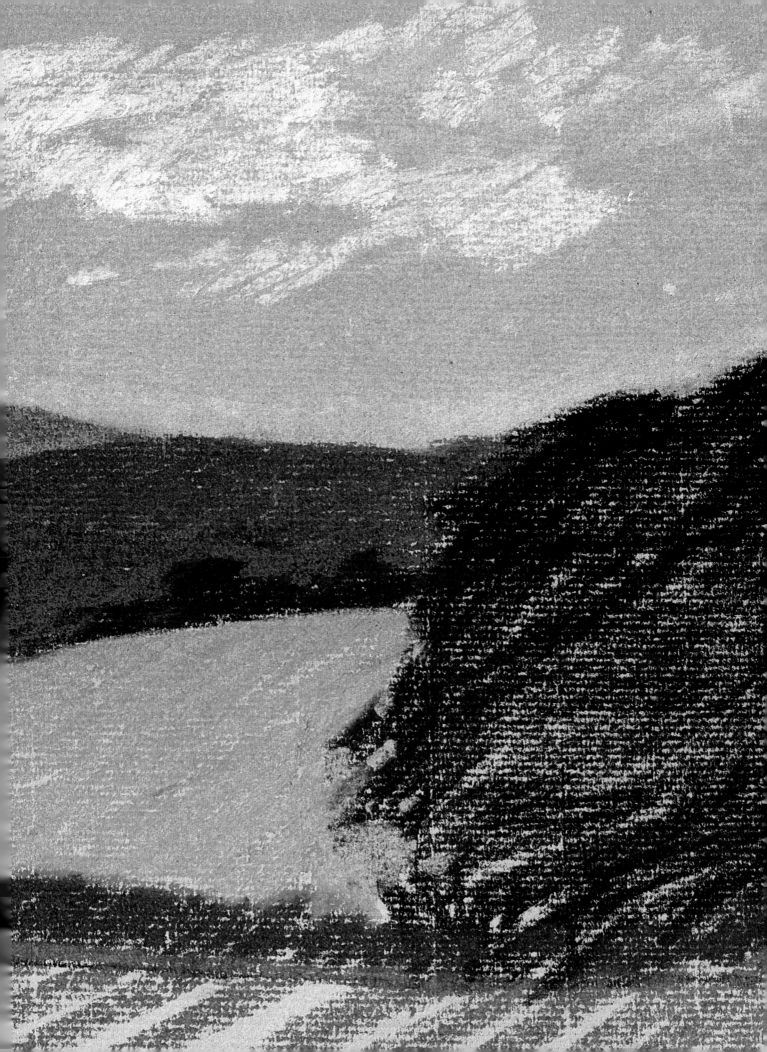

Drawing techniques

PERSPECTIVE

Fairly accurate drawing forms the basis for the majority of representational paintings and in order to do this you need to make believable on paper what you see in reality. All objects, animate or inanimate, have depth, height and width to a greater or lesser degree and it is these three dimensions that you need to translate realistically on to a flat piece of paper or support before you can build up any form or shape.

The guidelines that artists use to give spatial dimension to their pictures are based on the system of perspective.

Linear perspective

Linear perspective provides a framework and logical structure for all the elements of your picture. It is based on the theory that all parallel lines converge and then meet at a point in the distance known as the vanishing point. Along the length of those lines objects in the background will look proportionately smaller than those in the foreground.

You can test the theory of one-point perspective for yourself by standing in the middle of a long straight road and looking into the distance. Notice how the sides of the road seem to come

together when they are at eye level on the horizon then disappear from sight.

Two-point perspective advances the theory further. When two planes of an object can be seen then there will be two vanishing points.

Sometimes an object may be above or below the horizon, that is you are looking up to it or down on it, and in this case there will be three vanishing points.

Cubes are often chosen to illustrate how perspective works because they have three planes, but more complicated objects may have many planes and each

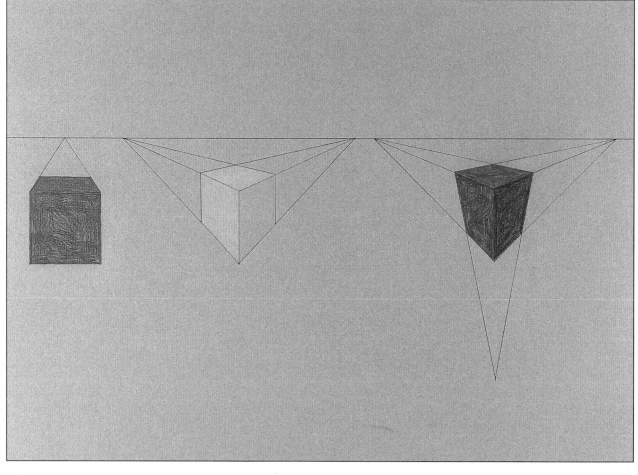

One-point perspective Two-point perspective Three-point perspective

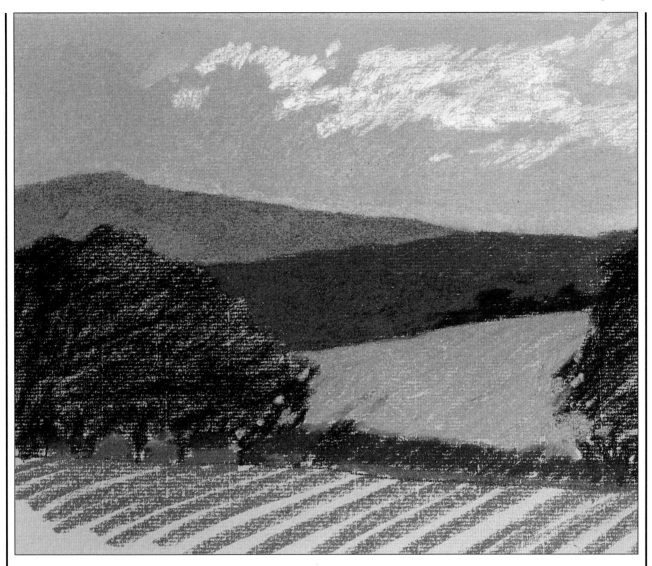

of these will have a vanishing point. This means that each part of your drawing must appear in perspective, not just the overall outline of your subject.

Aerial perspective

As objects recede into the distance so they seem to alter slightly in colour and tone, taking on a soft bluish tinge.

The change in the way we perceive objects is due to the scattering of light waves caused by the density of the atmosphere and the amount of dust and moisture it contains. This effect, known as aerial perspective, is particularly noticeable if you look into the distance on a hot hazy day. The atmosphere holds condensed water vapour, making mountains and hills appear to be more muted and bluer the further away they are.

Aerial perspective plays an important role in landscape painting where blurring and softening objects in the far distance and adding a little blue to them helps to establish pictorial depth, but it can also be used to good effect in any painting where recession is required.

FORM AND SHAPE

Perspective can provide the outline dimensions of an object but in order for it to appear real it must also look solid.

When we see an object in real life we are able to distinguish its solidity because of the amount of light and shadow that falls on it, giving it dimensional shape. In drawing and painting the artist must reproduce this effect of light and shadow through shading and highlights, or form.

The areas of light and shadow on an object vary according to the amount of light it is receiving and the direction from which the light is coming. Those areas nearest the light will have the brightest highlights while those farthest away will be in deepest shadow. On a square shape with flat sides such as a cube this will create defined areas of tone, from light to dark, but on a curved surface there will be a gradual increase in the tonal value as the area of light changes to dark.

It is very easy to think of light and shadow as white and black with a variety of grey tones in between, but this is true only when painting in black and white. All colours have a range of tonal values. Many objects contain a number of different colours and each of these colours will be of a different tone depending on its position with regard to the light.

On this page four apples are illustrated, all of which have light falling on them from the same direction, but in varying amounts. The apples are in tones of green and red and the shading on their curved surfaces ranges gradually from highlight to deep shadow.

A different pastel technique has been used to render each apple to demonstrate the variety in form and texture that can be achieved.

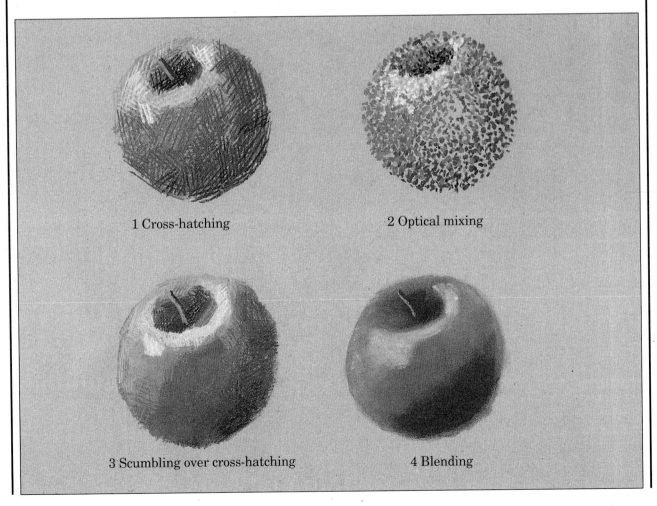

1 Cross-hatching

2 Optical mixing

3 Scumbling over cross-hatching

4 Blending

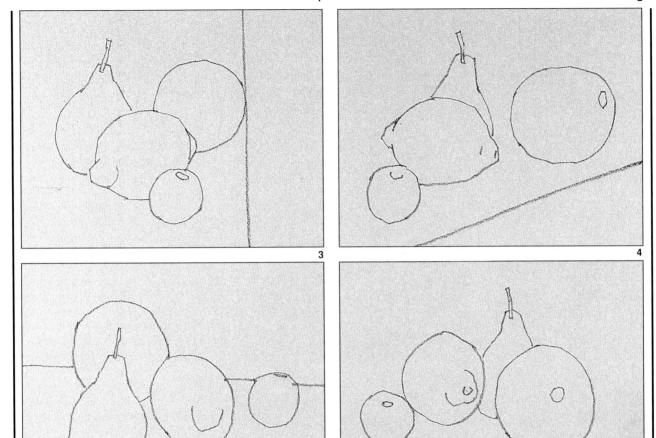

Composition

Form helps to establish the shape of an individual object, but it is also important when arranging a group of objects into a composition so that the various shapes can relate to each other in a way that pleases you. Thought must be given to light and shadow to ensure that there is tonal balance in the picture and that consistent sources of light are suggested.

Another important aspect in composition is planning the relationship of the objects to their setting. A useful way of checking that you are arranging your composition in the most satisfactory way is to look at it from different viewpoints. In the four pastel sketches on this page the artist has arranged a selection of fruit on a table and then moved his viewpoint to see which would make the best composition for a painting.

1 In the first drawing the edge of the table seems to bear no relationship to the fruit at all and the various pieces seem to float in mid air.

2 In the second drawing the table slices off the picture space and leads the eye out of the picture to the right.

3 In the third drawing the table edge is at eye level, but there is no real variety of shape on the 'horizon' to hold the viewer's interest.

4 The composition is much better in the fourth drawing. The edge of the table leads the eye into the picture and visually anchors the fruit. As well as making the most of the variety of shapes interesting detail can also be seen on each piece.

Proportion

Perhaps the key factor in drawing the human figure is to get the general proportions correct before starting to look at individuals and their particular features. It is generally considered that the head fits into the body seven times, but on paper this produces a rather stocky-looking person. Conventionally artists will draw a figure into which eight 'heads' can fit and as a result the general proportions of the figure are aesthetically more pleasing.

The guideline on general proportion has some exceptions, of course. When drawing a child you will notice that its head is much larger in proportion to its body.

It is also important to draw the trunk and limbs in proportion to the whole body so that the figure is correctly balanced. For instance, the arms are probably much longer than you think and the waist higher.

Everyone is different, but

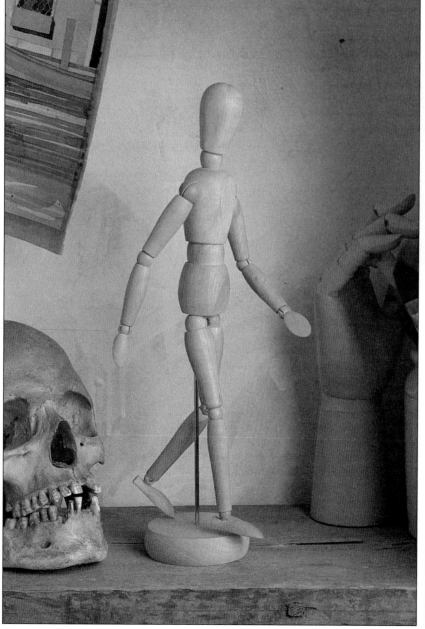

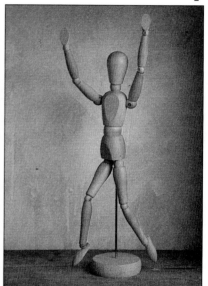

1 Walking
2 Running
3 Jumping

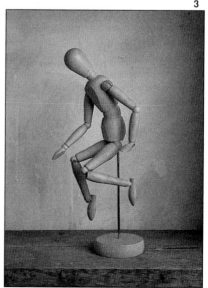

once you have an idea of general proportions you will find it easier to draw figures as individuals.

Using a lay figure

Many artists use a lay figure to help them get proportions right. This can be very helpful if you are drawing a figure in action. Movement is difficult to record accurately because it happens so fast and as muscles and limbs move and co-ordinate so they can appear foreshortened, changing the general proportions and outlines. In the photographs here the artist has arranged the lay figure to show the typical movements for walking, running and jumping.

A lay figure is made up of all the main sections of the body including the joints which enable us to move. Thus it can demonstrate a complete range of natural poses. This is very useful if you cannot find a live model or wish to draw a pose which is difficult or tiring for someone and, of course, means that you can spend as much time as you like over your drawing.

Using a wooden dummy like this for drawing purposes also brings home the complexity of the human figure. In fact it is really a series of joined shapes which move and balance together like the pieces of a well-oiled mechanism. Try looking at a pose from a variety of viewpoints and you will notice that as one section moves off balance another will compensate.

An interesting exercise is to draw each section as a cylinder shape and to note the effect of perspective on it when you change the planes or the viewpoint. Drawing in cylinders is also good practice for establishing form. All parts of the body are curved and so display gradated areas of light and shadow. You can experiment with different light sources such as table lamps, torches and candles. Make sure that you vary the pose of the lay figure so that you can see these different effects on a figure that is bending, sitting or kneeling as parts of the body throw their shadows across the whole. If you change the direction of the light to a variety of angles above and below the figure you can produce some interesting and inspirational effects.

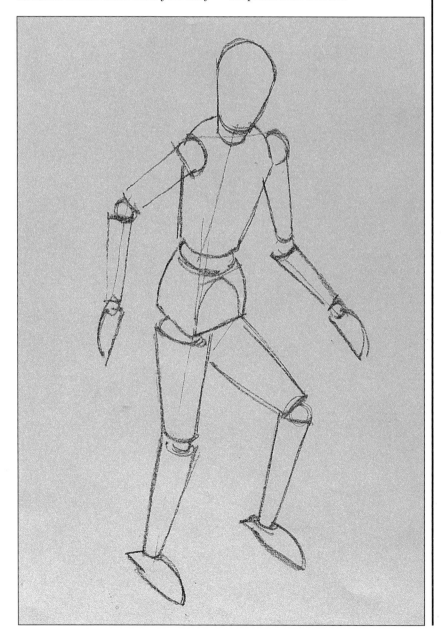

SKETCHING

The best way to learn to draw with accuracy and with ease is to practise, and that means to sketch at every available opportunity. There is absolutely no substitute for sketching, and pastels are an ideal medium. They enable you to make quick colour line drawings and to shade your sketches in a matter of moments. Indeed, the more proficient you are at drawing the quicker you will become and the more sure your results.

Try to take your pastels with you whenever possible, or at least a pencil and notebook so

that you can make sketches to turn into pastel drawings or paintings. If you see a subject that inspires you to paint later make notes on the colours, shapes, direction of light and other details so that you can re-create the scene as nearly as possible.

There is no shortage of subject matter, and one subject which will serve you well is the human face. While you may be able to practise drawing the human figure and the way it moves from a lay figure this will give you no clue at all about

people's facial features. Observe people carefully, for the human face also has proportions which must be considered and features will look odd if not drawn in correct relation to others.

One good source of reference material is the television. Think of the number of faces that can be sketched in just one evening sitting at home. Many of them flash on to the screens for just a few seconds, but interviews and news programmes give you the chance to study faces for longer.

Days out at sporting events, walks in the country, visits to

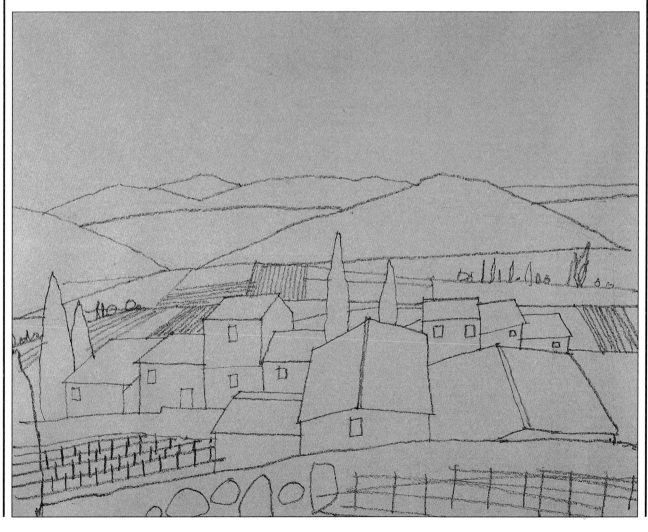

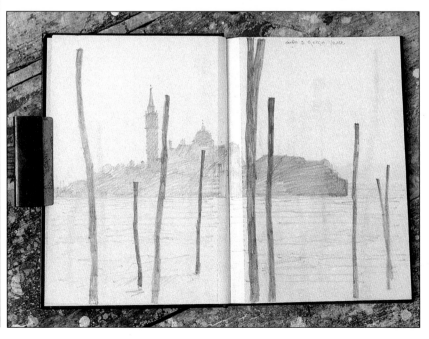

wildlife parks and nature reserves and even visits to art galleries can all provide you with sketching material and inspiration to practise your pastel techniques. Look at buildings and work out the perspective and vanishing points and areas of shadow. Drawing is a process of ever learning, and trying, and the more you sketch the sharper your eye and the more successful your art.

Chapter 4
Colour

After drawing, the most important element in painting is colour.

Colour permeates every part of our lives. We use it to express our emotions, to decorate our homes and ourselves, from the palest of tints to the brightest of hues. Yet when we start to paint we often seem to be overwhelmed by choice and spend precious time trying to match up the tones we think we should be using rather than exercising our eyes.

If you are going to get the most out of your pastels then it is fun to explore as many combinations of colour as you can.

Colours change when placed in proximity to each other and the variety of effects you can achieve is infinite. A colour wheel is a helpful device and will give you practice in blending. Plan each painting as an individual composition in which colour plays a major role, emphasizing and balancing within the picture to convey warmth, coolness and mood.

Remember that light and shade are also colours. The Impressionists delighted in the possibilities of using colour to portray light, and even a brief study of their paintings will repay you in inspiration.

Colour

THE DIMENSION OF COLOUR

When artists speak of colour they use specific terms and categories to describe exactly what they mean. It is helpful to have a basic understanding of these terms so that you can develop your use of colour to its full potential.

There are three colours, or hues, which cannot be mixed from other colours. These are red, blue and yellow and are known as the primary colours. All other colours can be mixed from varying amounts of these three primary colours.

If you mix equal amounts of two primary colours you produce a secondary colour. Thus red and blue produce violet, red and yellow produce orange, and blue and yellow produce green.

By mixing all three primary colours together in varying amounts you can produce what are termed tertiary colours. These are a range of more subdued colours such as burnt orange and olive green in addition to numerous browns.

You will probably find it useful to make your own colour wheel or chart to see how all these colours mix in practice.

Colours that are near to each other on the colour wheel, for example red, orange and yellow or yellow, green and blue, are termed harmonious colours. Those that are opposite on the wheel, for example blue and orange or yellow and violet, are termed complementary colours. When two complementary colours are mixed together they produce a neutral grey colour. Much of the theory of colour revolves around the use and juxtaposition of harmonious and complementary colours.

Artists also speak of the temperature of a colour. Those based around orange on the colour wheel are considered to be warm colours, while blues and greens are felt to be cold or cool. A skilful use of warm or cold colours may have a strong visual and psychological effect in a painting.

The lightness or darkness of a colour is measured by its tone. When a hue is mixed with white to make it lighter the resulting colour is known as a tint, while a hue mixed with black to make it darker produces a colour known as a shade. It is an interesting exercise to see how many tonal values you can give to one colour by adding gradated amounts of it to white or by adding gradated amounts of black to the colour.

Learning to mix colours is part of the fun of painting and becoming familiar with just some of the infinite range of hues and tones is a major step towards discovering how to use them to best effect in your paintings.

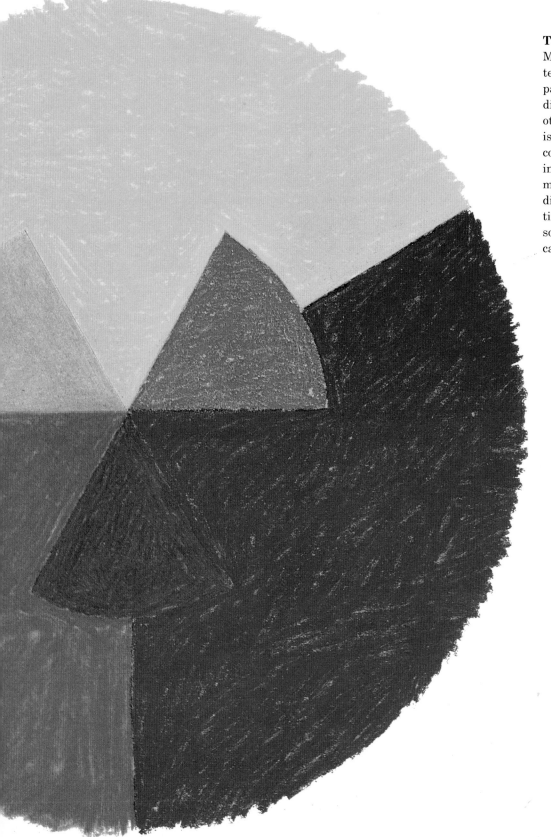

The colour wheel
Mixing secondary and tertiary colours with pastels requires a slightly different technique from other paints. The pigment is applied dry and the colours need to be built up in layers and blended, or mixed visually from a distance. A huge range of tints is available and some very subtle tones can be achieved.

USING COLOUR

Volumes have been written on the subject of colour theory, but if you have at least some practical experience of the way colours work visually then you can approach your painting with some confidence.

Colour can be used to establish distance and movement within a painting and the painted squares within squares shown here demonstrate clearly how our perceptions can alter quite radically when two colours are juxtaposed next to each other. Try painting a series of squares to experiment with harmonious, complementary, warm and cold colours and tones to build up some colour reference of your own.

The use of one colour always has some effect on another in the same painting. When complementary colours are used next to each other they appear to make the other colour look brighter. Thus you can enrich the colour of an object by painting its shadow in its complementary colour.

An orange, for instance, will look even more orange if it is painted casting a blue shadow.

The natural, or local, colour of an object can also be tinted by colour that is reflected on to it. This happens when a bright, dominant colour is placed next to it. If you hold a buttercup under someone's chin then you will see the effect of reflected colour.

Remember that all colours change according to the light conditions both indoors and outside, so always observe carefully before you start to paint your subject.

In *The Lerolle Sisters*, Renoir (1841–1919) boldly juxtaposes complementary colours to intensify both the orange and blue tones.

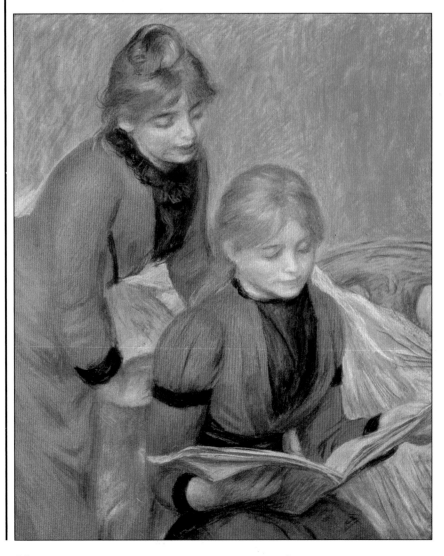

It is generally accepted that
cooler, darker colours recede or
move into the background and
warmer, brighter colours advance
or move into the foreground.
The two columns of squares show
pairs of colours painted together
and appear to bear out this theory.
In the left-hand column the inner
squares advance and in the
right-hand column the inner
squares recede.

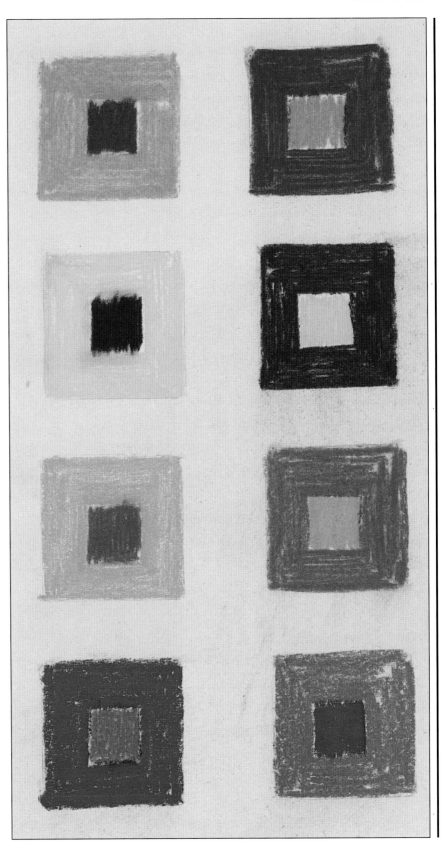

39

There is no need to buy a large number of pastels to have a wide range of colours and tones to hand, for the art of pastels lies in mixing and blending.

If you intend to specialize in landscape or portrait painting then boxes of a dozen or so pastels are available with the appropriate colours and tones already selected. You can also buy a box with an assorted selection. It is far more satisfying, however, to choose your own and to spend some time just working out a few of the new colours this will enable you to mix.

Here the artist chose to make a limited palette of ten colours, and shows that by mixing just two colours together you can achieve numerous new ones. Those illustrated here are just some of the possibilities. The ten pastels he chose were:

Poppy Red 8
Crimson Lake 6
Mauve 5
Cobalt Blue 6
Yellow Ochre 6
Lemon Yellow 6
Lizard Green 8 and 3
Burnt Umber 4
Vandyke Brown 8

These colours form a useful base from which to work, but you may wish to make your own selection. Every artist has different colour preferences and requires a palette suited to expressing their own style and choice of subject.

You can also choose to limit your palette entirely to one colour. Working in monochrome does not limit you to black and white, however, for you can choose to paint in tints of any colour. You might wish to try the colours of black, white and red that were used to such effect by Leonardo and other Renaissance painters or to use a range of browns and try to reproduce the sepia effects of old photographs.

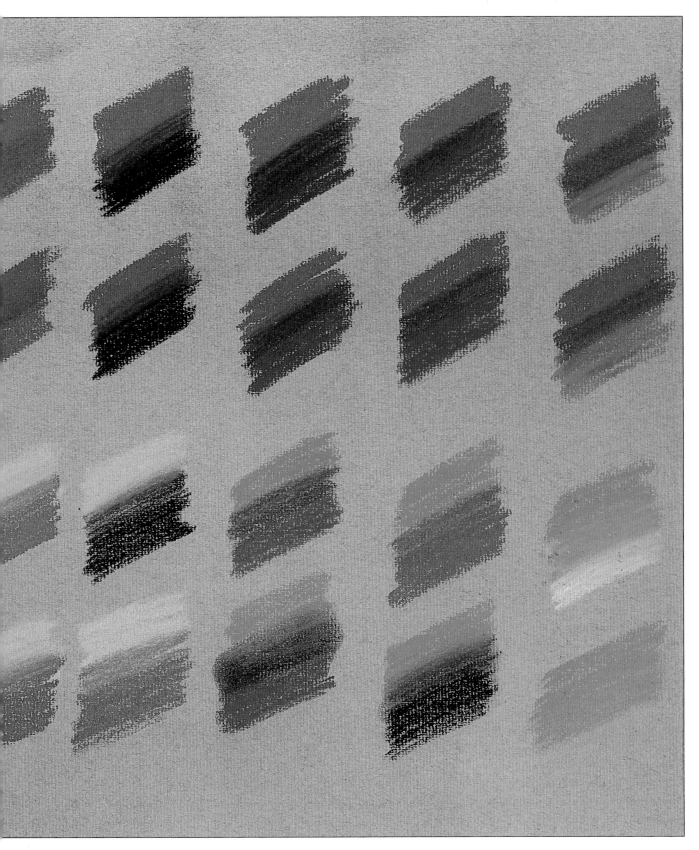

Just as the colours of pastels change when they are placed next to other colours, so they show differences when used on coloured papers or supports.

On these pages the artist has drawn across a series of coloured papers with three pastels — red, blue and yellow — and you can see how the background colour alters the effect, appearing to produce lighter or darker tones.

In pastel painting, perhaps more than with any other medium, the colour of the background paper or support can play a crucial role in a picture. Since pastel is applied dry and needs to be used on a paper with a toothed surface there are always areas of the background that are left uncovered, so the colour shows through and mixes with the tones of the pastels. This makes the choice of background support quite important and you should select the colour of your paper bearing in mind the final effect you want to achieve and whether a warm or cool toned undercolour is the most suitable.

Tinting your own support gives you the advantage of being able to choose a precise colour or tone. Many of the commercially available coloured papers are subtle in colour and you might prefer a brighter hue.

This is done by simply crushing pieces of broken pastel, dipping a damp cloth into the powdered pigment and rubbing it evenly over the surface of the paper. When the 'wash' is dry just give the paper a little shake to check that there is no loose powder, and it is ready for use.

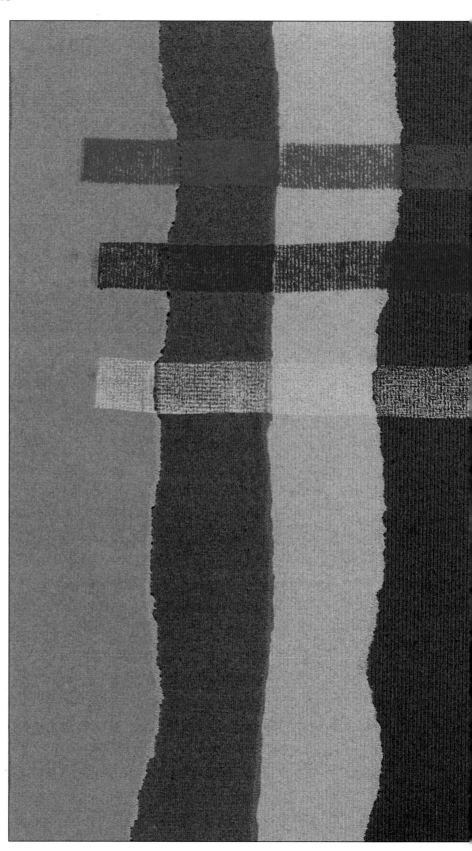

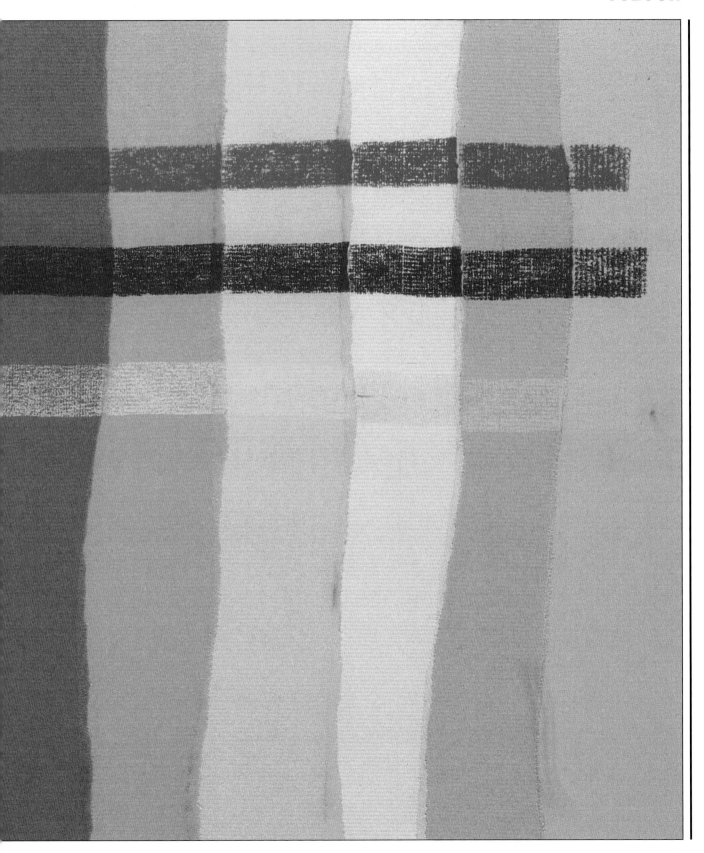

Chapter 5
Pastel techniques

Much of the enjoyment of pastels lies in the variety of ways they enable you to express your own creative style, and just a glance at the work of famous painters gives some indication of what can be achieved.

Combinations of tones and hues can be placed one on another, side by side, or built up in layers to give dimension and depth, mood and movement. Pastels can be used on their ends like pencils and crayons to create effects through line or on their sides for wonderful expanses of colour.

This chapter presents a number of tried and tested techniques to get you started. You may like to experiment with them all before you really get going, or select one or two that particularly appeal. In either case it is advisable to try them out on a spare piece of paper before using them in your artwork. As well as discovering the different effects you can produce this helps sort out how much pressure you need to apply to your surface. Learning to work with pastels is much easier if the layers of pigment are not too thick, giving you control over the finish of your paintings.

Pastel techniques
USING END OF PASTEL

Here, the artist is using a square pastel on its end to produce firm, broad marks. It is important to control the amount of pressure you put on the pastel so that you can easily mix or blend the colours if you require. This also means that you will not waste pigment unnecessarily.

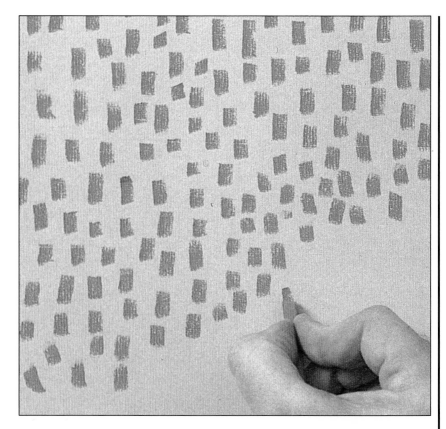

The corner of a square pastel is used for more deft strokes which suggest movement. This way of holding and using the pastel is useful for fast on-the-spot sketches.

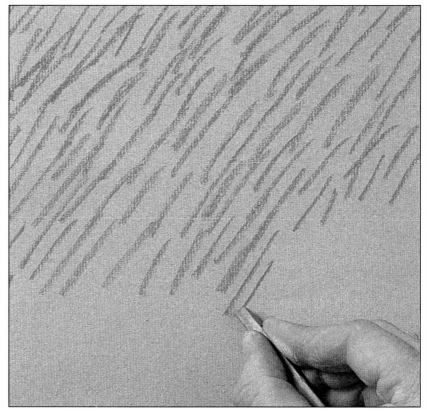

By pulling down on the side of a
square pastel you can make long
irregular strokes. This technique is
ideal for filling in areas where you
want the background support to
show through, or for adding other
colours to build up the texture.

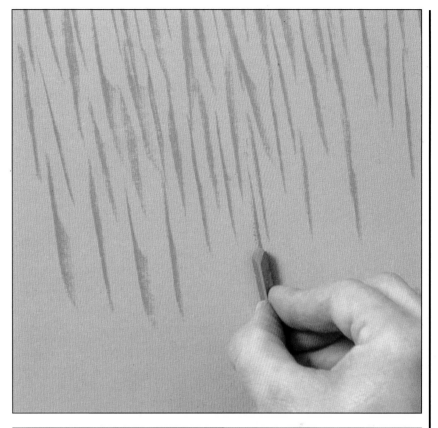

Large areas can be filled in quickly
by sweeping over them with the
side of the pastel. A square edge
gives a slightly broken effect to the
colour.

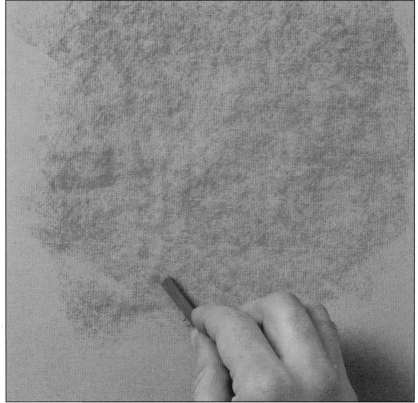

HATCHING

1 Hatching is a simple way of producing a textured look by working small regular strokes in the same direction across the paper.

2 A second colour can be hatched on top of the first, keeping the strokes the same length and working in the same direction to build up the texture. Be careful not to overdo this as it is all too easy to make the mixture of colours look muddy.

1 Cross-hatching is the technique of hatching small blocks across the paper in different directions so they cross one another. It produces a cleanly worked finish and is useful for illustrating textured shading.

2 A second colour can be cross-hatched across the first. This is particularly successful if the first layer is darker as it gives added depth.

3 Here, a third colour is being cross-hatched over two previous layers. Small areas of thicker pigment seem to break through the surface of the texture with intensity.

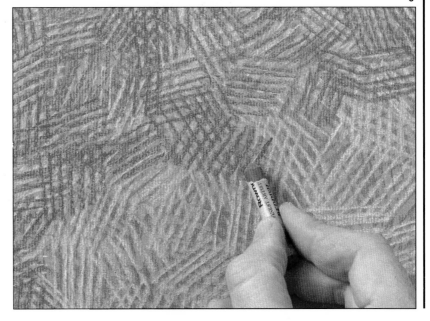

LAYING FLAT COLOUR

1 It is often useful to lay a surface of flat colour as a background. Use the side of the pastel to rub colour evenly all over the surface of the support. Cover the area by working in the same direction and try not to be too heavy-handed as a thick layer of pigment is less likely to adhere to the support.

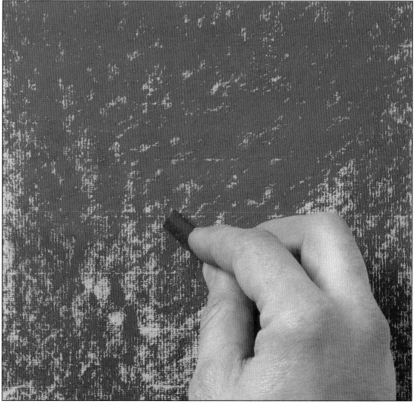

2 A second coat may be applied on top of the first. It is much more effective to build up the surface in this way rather than covering the support densely in one go. The more textured the support, the more likely you will see parts of it showing through, so it is important to choose its colour carefully so that you can achieve a satisfying result.

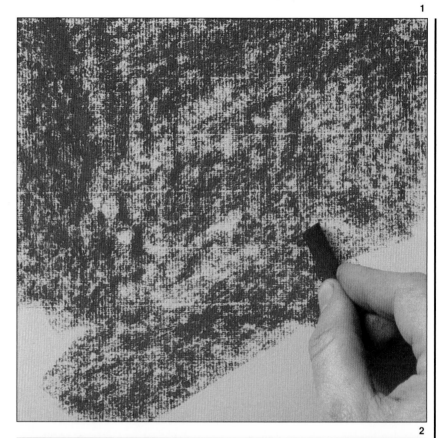

The Impressionists developed the theory of optical mixing. By placing blobs of varying tones of colours next to one another their paintings seemed to acquire a depth and sparkle when viewed from a distance.

The artist Seurat developed this technique further, juxtaposing small dots of primary colours which appeared to mix into clean, bright secondary colours. You can try this technique yourself, using different combinations of colours.

Harmonious colours from the warm part of the spectrum seem to increase in brilliance when seen from some way away.

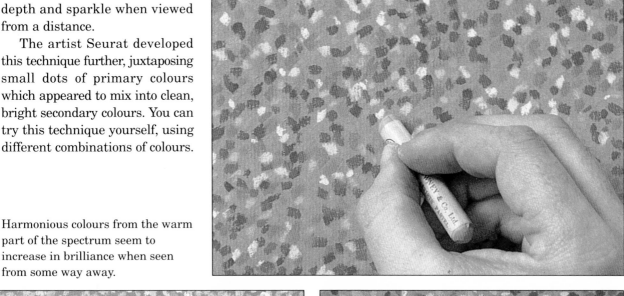

A variety of tones of yellow appear to produce a colour that is more intense.

By mixing blobs of blues and greens a shimmering effect is achieved.

SCRIBBLING

Scribbling with a pastel may sound a simple technique, and indeed it is. Yet some surprisingly advanced effects can be produced with this method of drawing.

Right Here, a dark yellow has been scribbled over the surface of the paper, and a second layer of a lighter tone is being scribbled over it. The result is an almost luminous quality.

Below It is always interesting to mix media to obtain a contrast in texture. Pencil scribbled over a flat layer of pastel produces an attractive shine.

The technique of scumbling enables you to mix or slightly modify the effect of a colour by covering it with a thin layer of another colour. This is usually light colour over dark or dark colour over light. It is applied with a rounded scribbling action.

Scumbling dark over light

Scumbling light over dark

SGRAFFITO

With sgraffito you scrape away parts of the top layer of colour to reveal the ground or colour beneath. A variety of instruments may be used depending on the width of line you want for your drawing or design.

The artist is here using a scalpel to scrape away one layer of pigment to reveal the coloured paper underneath. Great care is needed with this technique to avoid cutting through the support.

Sgraffito is most effective when several layers of pigment have been layered one on top of another. This example shows two layers of colour, and the artist can choose whether to remove them both or to scrape away the top layer only and reveal the one beneath it.

You may wish to soften the effect of a large area of pastel paint. This can be done very easily by gently sweeping a soft brush over the colour to remove the dry pigment. This technique is also useful for blending the more subtle areas of colour together.

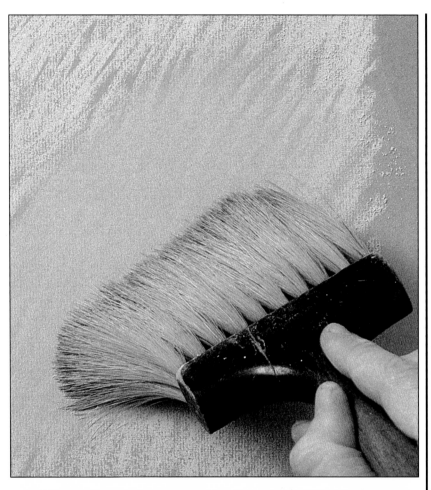

A way of removing smaller areas of pastel is to use a kneadable eraser. This useful item can be moulded into a point and used to produce a stipple effect.

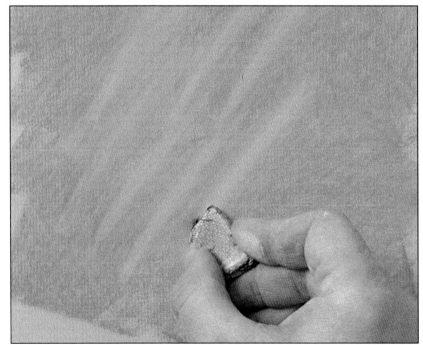

BLENDING

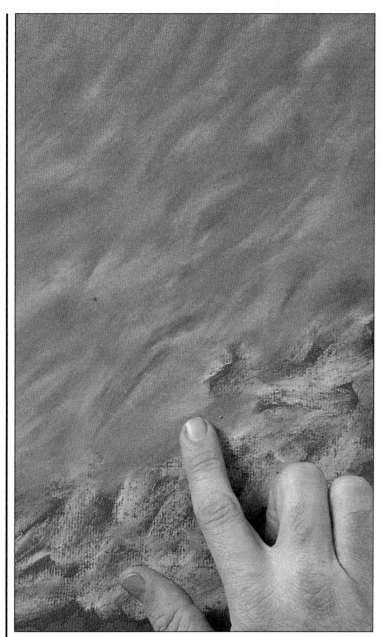

Above An effective method of mixing two layers of pigment is simply to use your finger. This allows you a great deal of control over your mixing, and some attractive cloudy effects can be produced.

Above right You can also use a torchon to blend pastel into the sort of tone you require.

Above If you are mixing two or more colours into one another it is again a simple matter to use your finger to blend. This technique is worth practising quite a lot so that you know the colours and tones that are likely to result from various combinations.

1 A further blending technique is possible with oil pastels. They can be dissolved into a 'wash' by brushing on and mixing in a little turpentine or white spirit. This also tends to enhance the brilliance of their colours. It is advisable not to overdo this technique, however, or you lose the texture that is so distinctive of pastel painting.

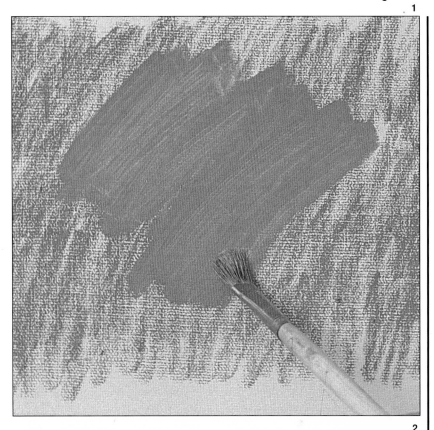

2 Here, the artist has mixed the oil pastel with turpentine and used the resultant 'wash' as a ground. Oil pastel is then applied on top in the usual way. The intensity of the colours is much enhanced.

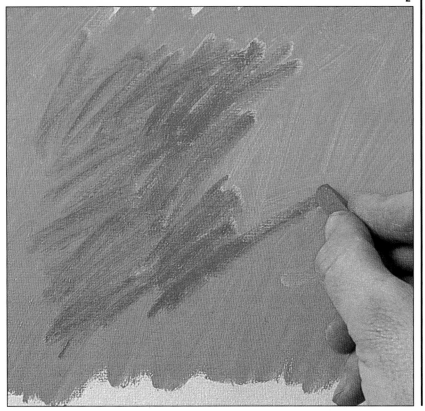

DRAWING TO A SHAPE

1 Sometimes you may wish to have a shaped outline to a particular part of your painting, and there is a simple method of achieving this. A piece of paper torn randomly or cut to a specific pattern is laid over the painting to mask off the area that is to be left. You then use the pastel in the usual way, making sure that you work it right over the edge of your mask.

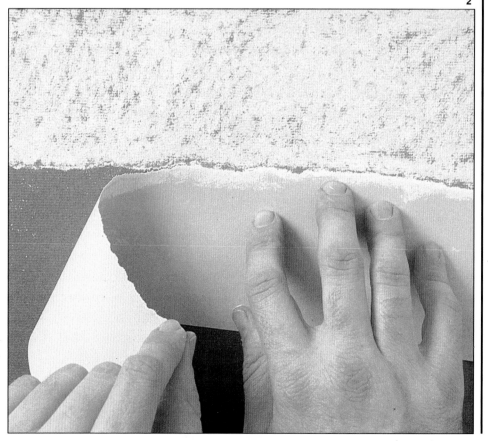

2 When you carefully remove the mask your chosen shape is revealed.

1 If you are thinking of framing your work you may wish to have a straight edge to your picture. This can be achieved by holding a ruler or straight piece of thin wood or metal along the support as you are working.

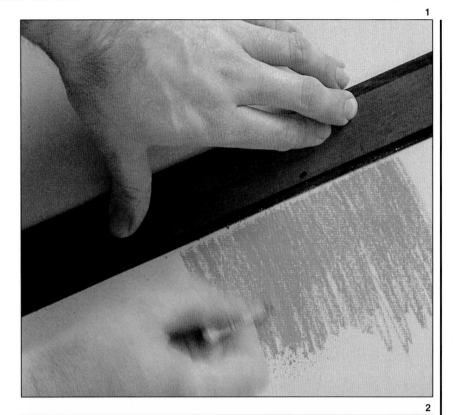

2 Remove the ruler and you will find a clear, straight edge. This technique can also be used for elements inside the painting, but take care not to smudge other areas of pastel.

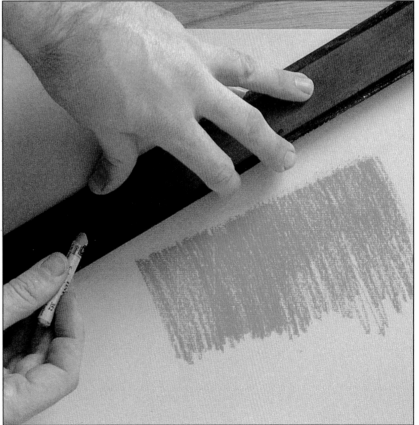

Chapter 6

Still life

A still life provides an ideal subject for the beginner in pastels and a chance for the experienced artist to try out new techniques. Almost any group of objects will do and the challenge lies in selecting items that will give you practice in interpreting colour, form and shape, light and shade, and texture. It can be fun to arrange everyday articles into a pleasing composition and to realize that you have never really looked at them properly before. But do try to choose something that will sustain your interest.

One of the great advantages of a still life as a subject is that you can take your time over it. You can set it up, work on your painting for as long as you like, leave it and then come back to it over and over again. Do not worry too much if you cannot get the details of your painting exactly as you want them at first. Your technical skills will gradually improve and so will your ability to plan your approach to colour, texture and shading. The most important point is that you get satisfaction and enjoyment from your painting.

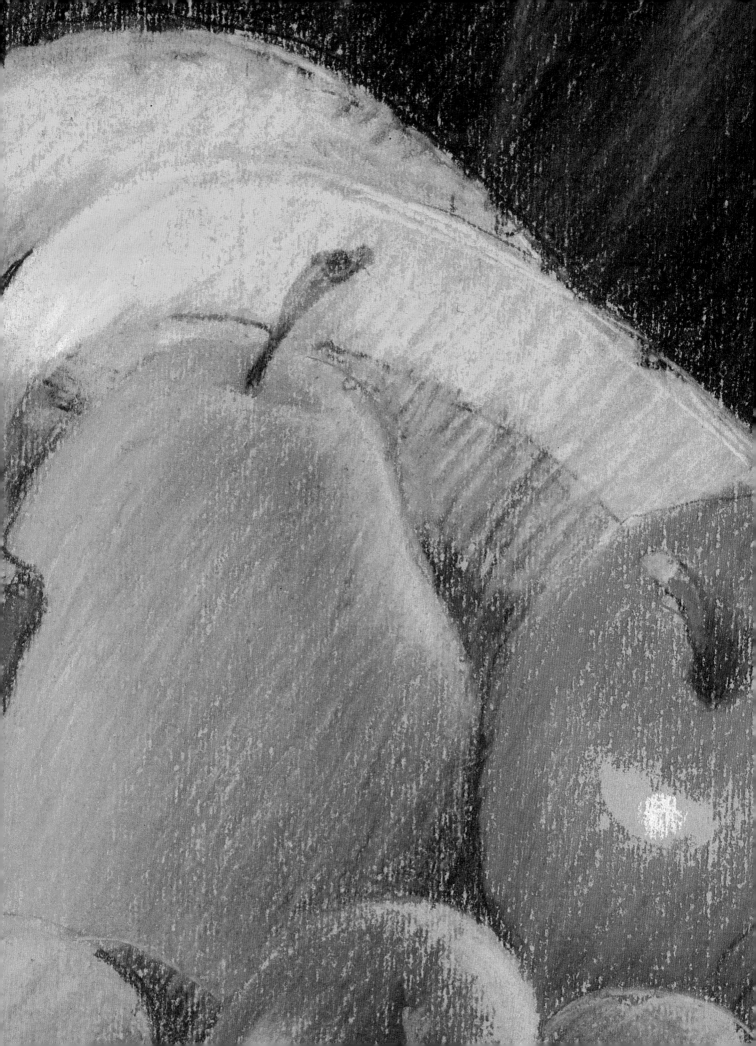

Anemones

STEP BY STEP

This cheerful bunch of anemones in a glass vase makes an ideal subject to help you get used to the feel of pastels. The bright colours will certainly hold your interest and give good practice in choosing a variety of tints to bring out the shape and form of the flower petals.

There are several interesting technical problems to sort out too. This picture shows how to paint a glass shape and its reflections without spoiling its clarity. The water in the glass is refracted as the stems of the anemones break its surface and are distorted below.

For this painting the artist has used a basic drawing technique, laying colour and putting in detail and highlights with the end of the pastel. The composition is simple, but is carefully planned, and by adding in background colour and the suggestion of the edge of a table the vase of flowers is firmly placed rather than appearing to float in mid air.

Colours

Silver White	Hooker's Green 5
Poppy Red 8, 6 and 1	Cobalt Blue 2
Mauve 3	Burnt Umber 2
Reddish Purple 3	Green Grey 4
Cool Grey 4 and 1	Intense Black
Lizard Green 3	
Yellow Green 5	

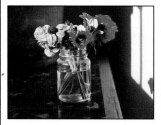

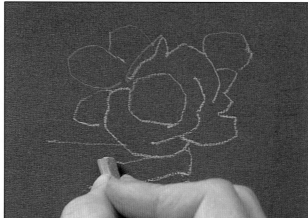

1 The artist starts work by sketching in the outline of the flowers. White is used so that the drawing will show clearly on the dark-coloured support.

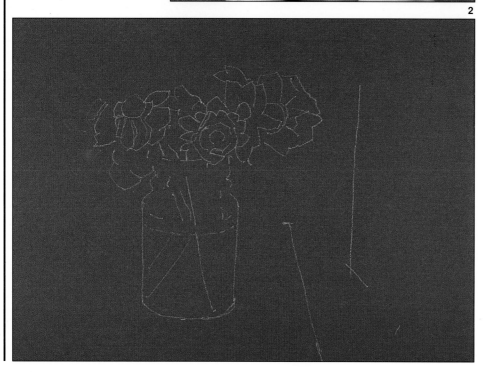

2 The whole composition is planned, marking the areas which will form the background and table.

3 Using the ends of the pastels, the basic shapes of the flower petals are blocked in.

4 With the petals blocked in, the stems are added. The stem lines break at the point where they enter the water, and a broken white line is drawn onto the glass to indicate the water level. A dash of colour is added to the neck of the vase as a reflection of the flower above.

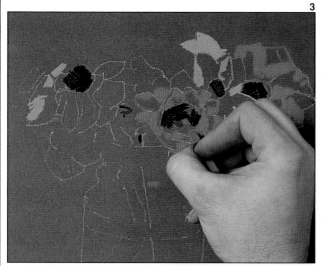

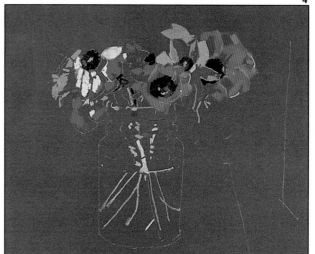

5 The artist continues to work on the glass vase, shaping it by adding highlights down the side in white and grey. One or two spots of colour are also put in to indicate curves and reflections in the glass.

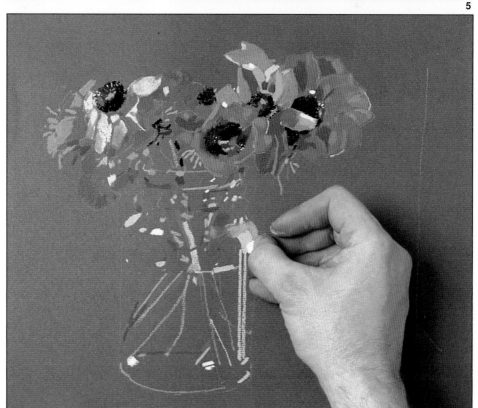

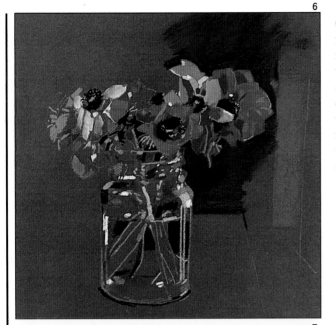

6 Part of the background is worked in. This increases the intensity of the flower colours and adds depth to the composition. From time to time a light covering of fixative is sprayed over the painting to hold the dry pigment.

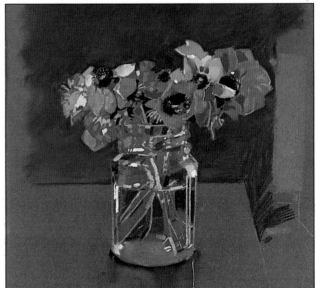

7 Further dashes of colour are added to the vase to suggest the prismatic reflections of the glass.

8 With the background worked in, the artist now outlines the shadow and muted reflections that the vase will throw forward.

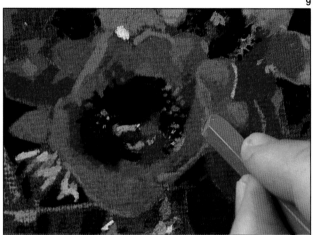

9

9 Final detail is added. Tones are layered and mixed with the end of the pastel, producing an almost silky, luminous quality.

10 Flat colour to suggest a table is laid either side of the vase's shadow. This gives the whole vase of flowers dimension and solidity and finishes off the painting.

10

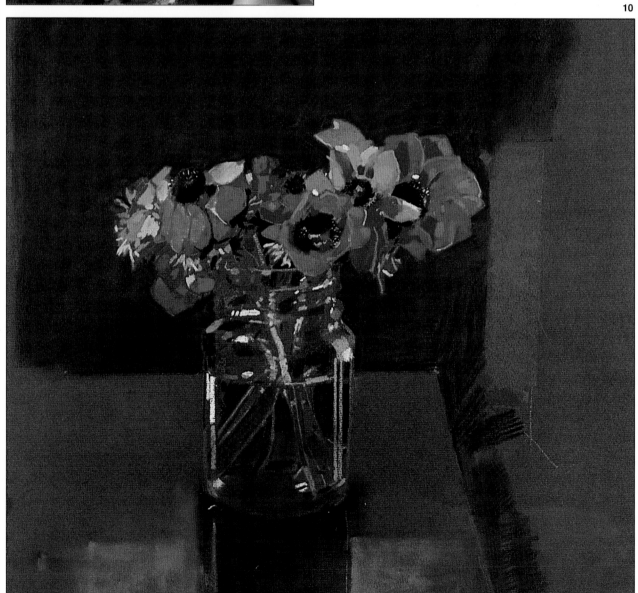

Bowl of fruit
STEP BY STEP

One of the classic subjects for a still life is an arrangement of fruit. The subtle variations in colour and different textures of their skins make them a challenge and a delight to paint. In the picture below, the fruit is piled high in a bowl, so that as well as a variety of shapes and sizes there is the added interest of shadow and masked outline.

There is an interesting selection of fruit here, each of which have typical features to portray. The shiny apple, plums, orange and lime all reflect bright highlights, while the pear and bananas are more subdued. All are rendered with a softly hatched technique. Strokes are all made in the same direction and blended together to create the texture, form and gradation of colour that is required.

A slightly looser technique is used for the heavy background material which serves as a contrast to the fruit. Colours are layered on top of one another and gently blended to form almost solid colour. The folds are worked in first to create shape and depth.

Colours
Yellow 105 and 108
Orange 113
Red 117 and 118
Red Violet 133
Violet 138 and 139

Green 155, 169 and 170
White

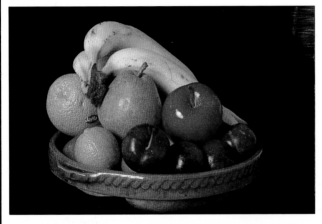

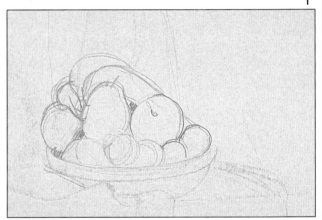

1 The outline of the fruit is sketched in first in orange. Then the strong outlines and deeper areas of shadow between the fruit are defined in red.

2 The most obvious colours for each fruit and the bowl are gently hatched in. For the background material a combination of a blue green and red is used. The colours are very loosely mixed one on top of another to produce the heavy folds.

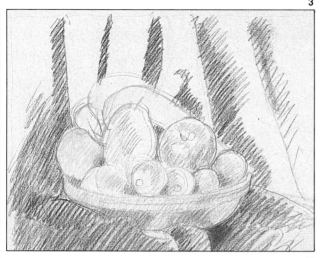

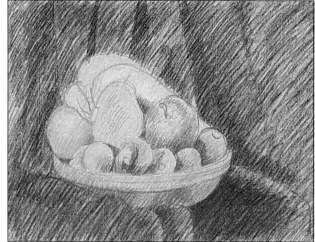

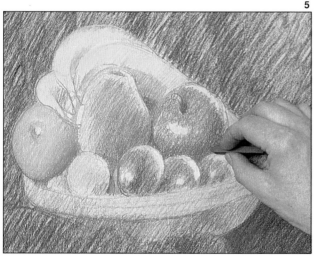

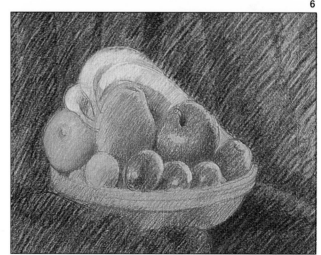

3 The material on which the bowl rests is worked in. Areas of highlight are shown on the fruit so that the artist can avoid putting colour in these places by mistake.

4 Further tones and colours are applied to the fruit, and the background material is beginning to be filled in as a whole.

5 More layers of colour are added and blended, and the gradation builds up to give shape and form. The artist starts to work in areas of shadow to define the various elements of the picture.

6 The composition is really beginning to take shape. The next stage will be to add detail to the individual pieces of fruit.

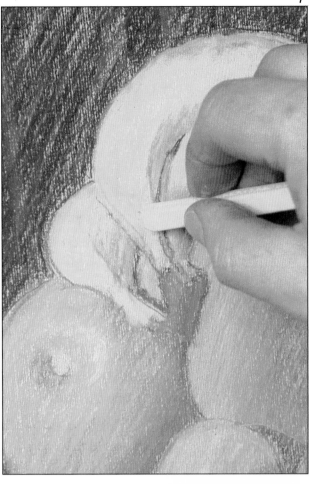

7 Yellow and green are blended together on the banana. The texture of the skin must look real if it is to be a convincing painting and the pigment is applied more thickly here than on the other fruit.

8 Bright white highlights are added to the apple to show its shiny skin. Highlights are also added to the plums, but these are more muted to suggest the natural bloom on these fruits.

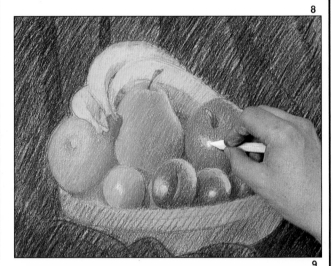

9 Highlight is added to the orange which has a waxy, granular look. The pastel has not been applied too thickly and the texture of the orange is enhanced by the small areas of paper that show through.

10 The edges of the fruit are carefully and thinly outlined in a darker tone to emphasize the shapes. Further layers of colour are still needed, especially on the material, to give more depth.

11 Finally the shadows which the pieces of fruit throw on one another are added in, and the stalks of the bananas, pear and apple are defined. The draped material now has a heavy richness that perfectly complements the luscious bowl of fruit.

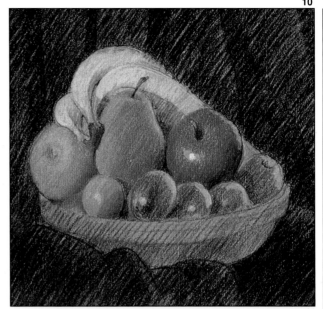
10

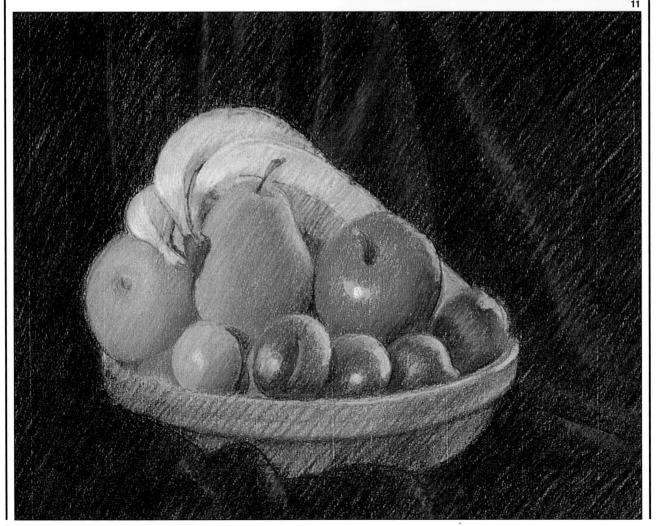
11

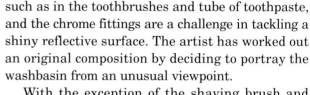

Washbasin

STEP BY STEP

A surprising number of everyday objects can provide interesting and useful subjects for a still-life painting. They can be really good practice, increasing your powers of observation and forcing you to see what is familiar in terms of light, shade, colour and texture.

At first sight a white washbasin surrounded by mainly white objects might not seem to offer much opportunity for colour, but the picture below demonstrates the number of subtle tones that can be found. There are odd splashes of bright colour too, such as in the toothbrushes and tube of toothpaste, and the chrome fittings are a challenge in tackling a shiny reflective surface. The artist has worked out an original composition by deciding to portray the washbasin from an unusual viewpoint.

With the exception of the shaving brush and toothbrush bristles the overall impression is of hard surfaces, yet this is achieved by using a soft technique. This allows the artist maximum control over detail and tone as the painting progresses.

Colours
Green 153, 155, 162 and 167
Violet 139
Red 121
Red Orange 116
Orange 113
Pink 130, 131 and 132
Blue 143 and 144
Yellow 102
Yellow Ochre 183
White

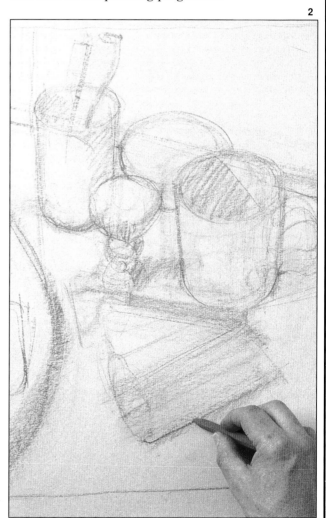

1 The artist chooses an interesting viewpoint and makes a thumbnail sketch to plan the composition. White china has a bluish tinge, so blue is used for this initial drawing.

2 Cylinder shapes are firmed up and start to look like functional objects. Their edges are delineated in red and orange to provide depth and contrast against the overall impression of blue.

Areas of shading are added and shadows suggested inside the mug and toothmug.

70

3 Before adding finer detail the pastel is sharpened to a point with a craft knife. The powdery pigment is kept safely and may be used later to tint a support for another painting.

4 The shape of the soap is now established and the artist starts to provide some detail. The red part of the label is coloured in.

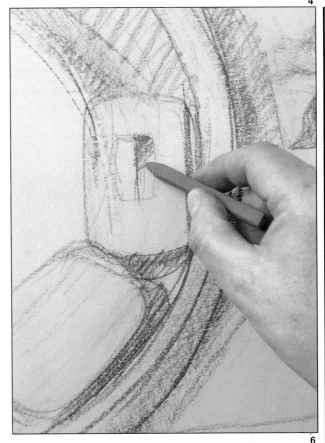

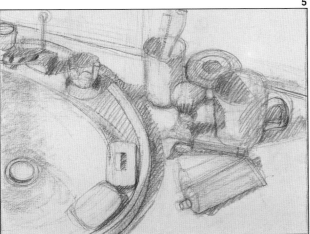

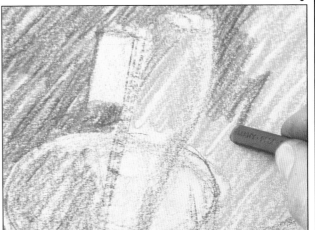

5 All the shapes of the objects have now been drawn in quite clearly, and so have the areas of shadow which will need to be worked on. The artist was originally uncertain exactly where to position the tube of toothpaste.

Notice that he has decided to move it slightly to the front and it now helps to lead the eye into the picture.

6 The basis for the tiled splashback is now added in. A layer of orange is put down, then covered with a layer of bluish green and the colours are mixed together. Further layers will be added later.

71

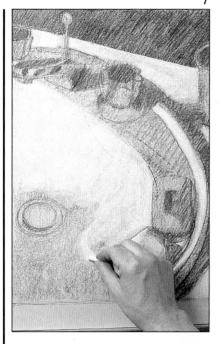

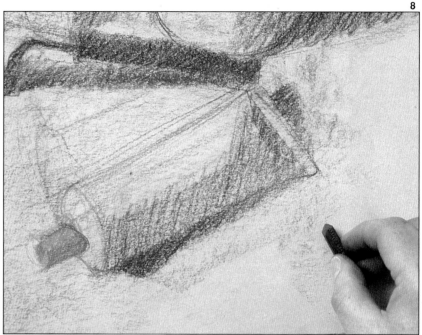

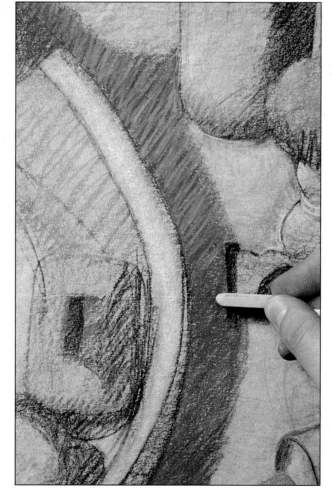

7 The texture of the china basin is achieved by a mixture of bluish green and red making a brownish tone, then scumbling over with white. The same colours are used for the chrome fittings.

8 Shading is added to give shape to the tube of toothpaste, and a first coat of orange is placed on the cap. Then the shadow thrown by the tube is worked in, the blue mixing with the orange and red that had been put in earlier.

9 Lilac is blended into the shadow around the basin to soften its outline. This technique will also be used for the small shelf inside the basin where the soap rests and for the area behind the taps.

10 The artist starts work on the mug, adding white around the rim to define its shape and to give an indication of white china. Close control is required and he rests his hand on a maulstick to avoid smudging other areas of the painting.

11 All the elements of the picture are now ready for final detailing. A little yellow is added to the basin to take the brilliance out of the white colour and to help give shape. It is also used on other areas of the painting to add a little warmth and depth.

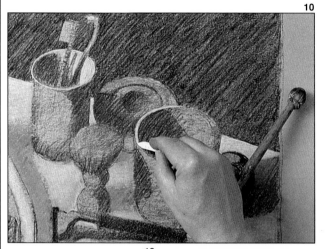

10

11

12

12 Yellow is added to the soap before blending in the colours.

13

13 After blending, the soap takes on a creamy, smooth texture and the shading denotes its moulded shape. The writing on the label is suggested, and the soap is complete.

14

15

16

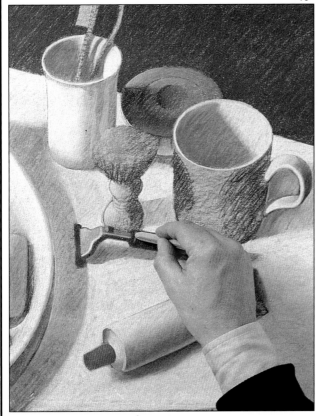

17

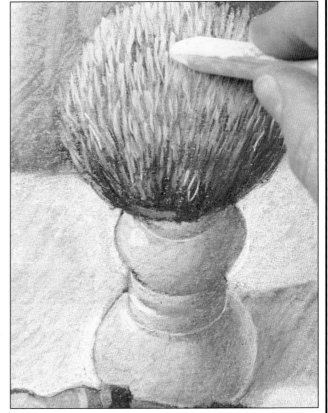

14 The finished soap is protected with a light spray of fixative. To avoid spoiling areas of the painting that still need to be worked on, a mask is cut to fit round it.

15 A little lilac is added to the chrome taps, plunger and plug to suggest their shiny surface. With white highlights, they reflect coloured patches of the items that surround them.

16 The toothpaste tube is fixed lightly to avoid smudging it while working on the razor. Blue highlights are added to the razor to emphasize the shape of the handle and shaft.

17 Now to finish off the shaving brush. The china handle is finished first and then the bristles are added in layers. Short strokes are used, keeping the colours lighter at the top. Again, a spray of fixative helps to preserve the final effect.

18 The mug has a scumbling of white and is now ready for its delicate decoration to be added.

19 Final decoration is added to the tube of toothpaste. To do this the artist makes sure that the end of the pastel has a sharp point, and rests his hand on the maulstick to avoid touching the finished part of the painting.

20 The finished picture. When painting a subject like this it is as well to check that you have included all necessary details. For instance, it would have been all too easy to forget the grouting for the tiles on the splashback or the lines between the tufts on the toothbrush.

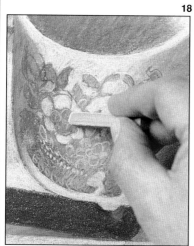

18

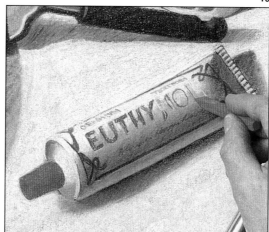

19

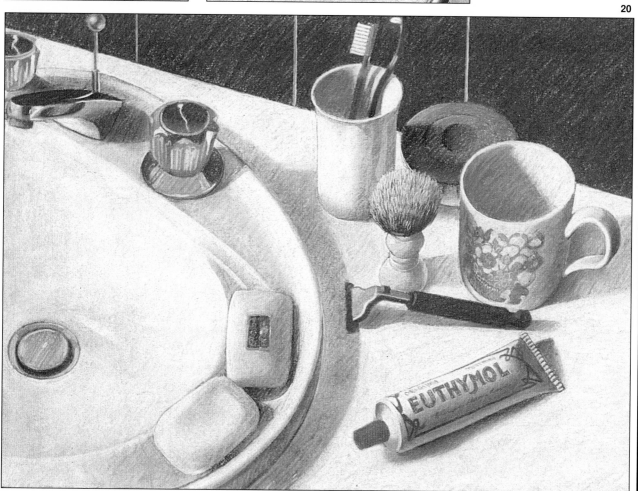

20

75

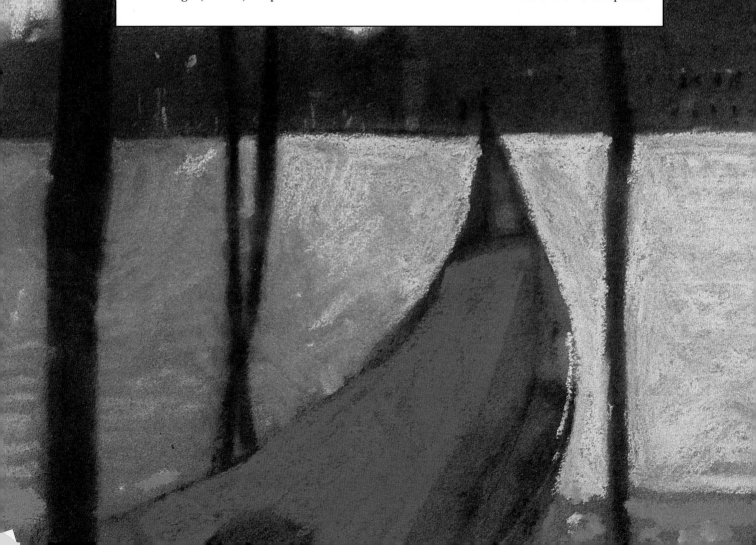

Chapter 7
Landscape

Generations of artists have expressed their emotions through nature, and even if you are not attracted by such romantic notions, landscape painting does give you an excuse for some relaxation in the fresh air and a souvenir of a memorable holiday or day out. It can also be one of the most challenging subjects, for nothing in nature remains completely static and the artist must be prepared to make the most of all opportunities.

The elements dictate your subject here. The sun, rain and wind all have some effect on the light, colour, shapes and forms in a landscape. Skies are constantly changing and you have to work quickly to capture interesting cloud formations and sunsets. Fields and meadows may have different patterns and colours on them as clouds pass over, and on a sunny day trees, hedges and buildings may throw deeply defined shadows. Trees have an amazing variety of hues and tones which change in the sunlight, so take time to observe them.

Water, too, is dependent on the weather and is always rewarding to paint, from the foamy wave patterns whipped up by a storm to the clear reflections on a millpond.

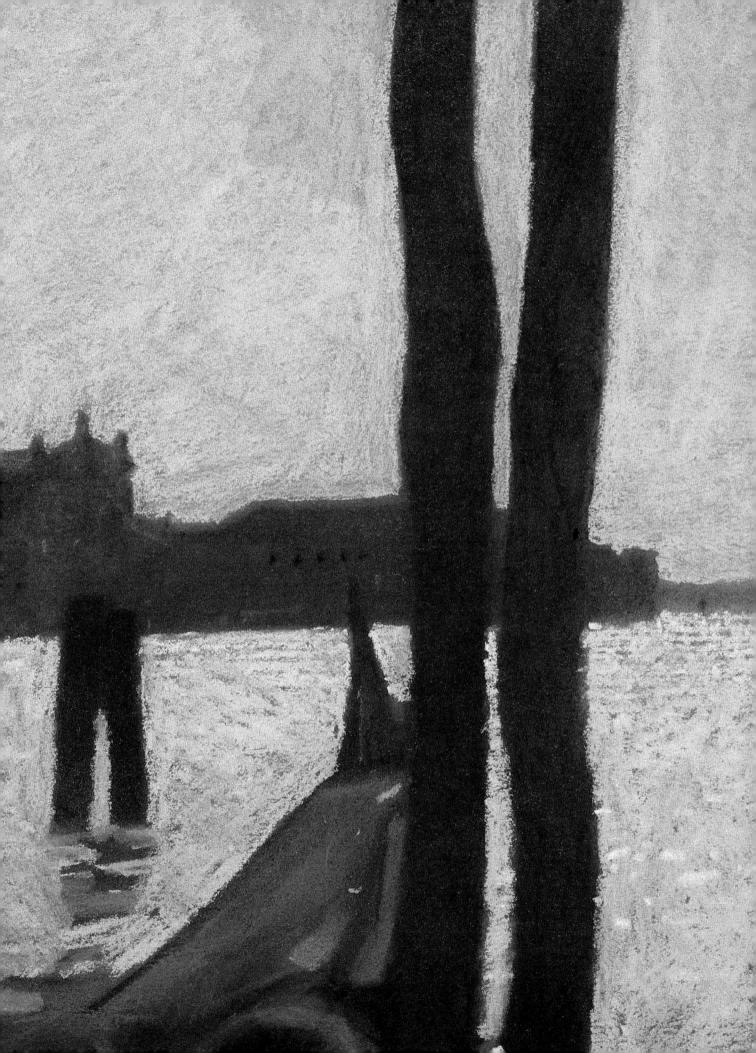

Rural scene

BASIC TECHNIQUES

This rural scene is the sort of subject you spot when you are out for a walk or a drive in the car and immediately want to record on paper. It is a simple landscape consisting of nothing more than a view across countryside to a clump of trees and on to hills in the far distance. Yet it forms the basis of a very satisfying picture which can be worked on there and then or recorded for completion later at home.

A sketchy style has been used, as befits the typical circumstances in which a scene like this would be painted. The pastels are used on end for drawing, and on their sides for large areas of soft colour. Colours are blended together, sometimes with the finger, to give a soft effect, and are worked in bands across the painting which increases the feeling of a wide expanse of space.

Colours
Phthalo Blue 7 and 9
Cobalt Blue 7
Blue Violet 7 and 8
Bluish Green 8
Phthalo Green 7 and 8

Burnt Umber 3
Light Yellow 5
Yellow Ochre 7

1 The scene is sketched directly on to paper, using blue to map out the different areas.

1

Above Both linear and aerial perspective are considered in this picture. The viewer looks straight across to a vanishing point on the horizon, where the hills are faintly seen with a bluish tinge.

2

2 A line of umber is blended in with the finger to denote the brow of the hill on which the trees are standing.

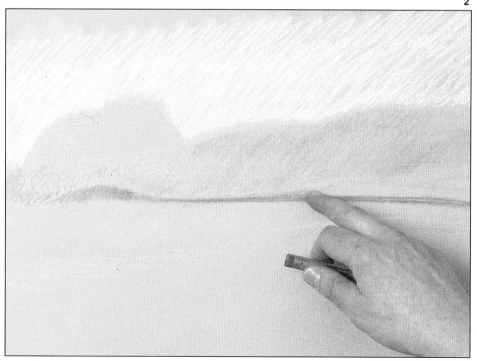

3 The bottom part of the sky is hatched in white. The area of grass in front of the trees is added in yellow, while the hill behind is coloured green to suggest the bluish look of far distance.

4 Now attention turns to the clump of trees. These are given a thin layer of umber pigment with the side of the pastel, producing a rounded sweeping silhouette. Although they are treated as a group a suggestion of trunks is outlined and the hillock on which they stand takes shape.

5 Using the ends of the pastels the fields in the foreground are coloured in loosely in blue and ochre, and the division between the two fields blended in green. Umber is used for the brow of the hill looking down on the valley and is applied by using the side of the pastel.

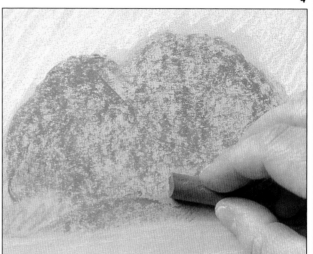

4

3

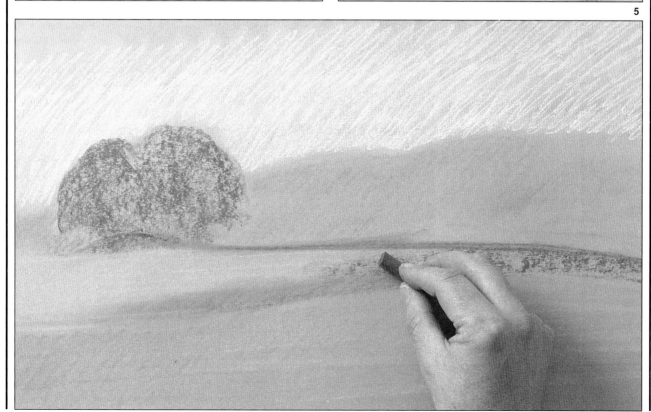

5

6

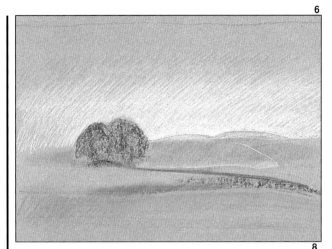

7

8

9

6 The artist now turns his attention to the sky, putting in a layer of sky blue so that it just overlaps the white layer. Fields in the valley begin to take shape as the white road into the distance is put in place and pale blue tones are used for the hills approaching the horizon.

7 Again using the pastel on its side, the artist sweeps in a broad expanse of bluish green for the distant hills.

8 Small areas of pale violet are scumbled in to give shadow and depth. Notice how the colour of the support shows through and seems to add a slight natural warmth.

9 A darker tone of blue is added to the sky, just overlapping the previous one and loosely mixed. The colours in the field are blended and details such as the line showing the brow of the hill are firmed up.

10 Detail is added to the individual trees. Thin lines for trunks are drawn in with a bluish green pastel and random strokes are taken through the foliage. A sharp pointed pastel is needed for this as clear definition is needed to achieve the required effect.

11 The artist now adds some detail to the foreground, drawing in long wavy lines quite evenly to suggest a furrowed field. These are done in a variety of colours, echoing the hills in the distance and bringing the various elements of the painting together.

12 This simple landscape was drawn and painted fairly quickly, yet there is plenty of detail to satisfy the eye.

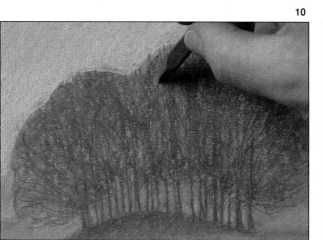

10

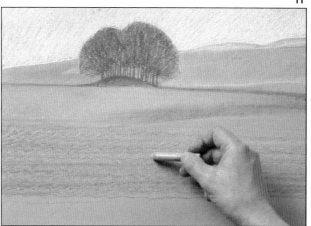

11

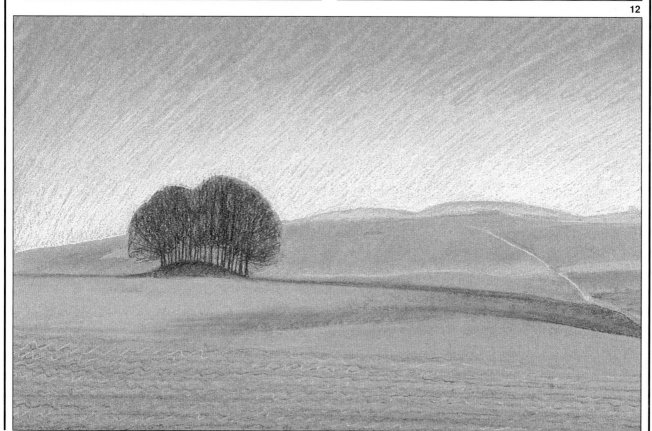

12

Woodland scene

STEP BY STEP

What a difference there is when you stroll through woodland on a fine summer's day with the sun filtering through the trees from a walk through the same wood on a dark winter's afternoon when branches are swaying and cracking in the wind. What marvellous subjects for painting, and what opportunities to match a technique to the mood of the scene.

In the painting shown here, the artist has chosen to illustrate a sunny day when the trees provide a cool retreat and the sunlight falls in dappled patches. He has used the technique of optical mixing, placing small spots of colour so that they merge and mix when seen from a distance. This has the effect of intensifying the colour so that it has a brilliant, shimmering quality.

The specific use of blue emphasizes the cool mood of the painting and also helps the feeling of recession and space established by the careful use of perspective. The eye follows the path down through the line of trees into the distance.

Colours
Yellow Ochre 2
Cobalt Blue 6 and 2
Cool Grey 1
Hooker's Green 8 and 1
Yellow Green 3
Intense Black
Silver White

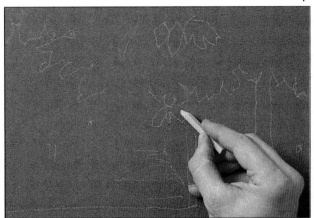

1

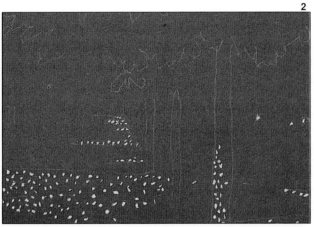

2

3

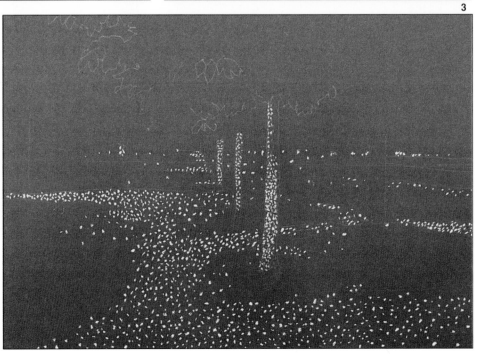

1 The artist starts by making a faint line drawing to indicate the various areas of the picture.

2 Small dots of light ochre are applied to the areas where the dappled light will fall. Some are also placed on the tree trunk in the foreground to help build its form.

3 Dots of light cobalt blue are added fairly randomly to the ground area, and to all the tree trunks. Already the colours begin to mix visually when seen from a distance.

4 Black dots are laid in the dark areas of shadow. The Impressionist painters believed that there was no such colour as black in nature and preferred to mix very dark tones optically, but it is not advisable to be purist about this unless you have perfected your technique.

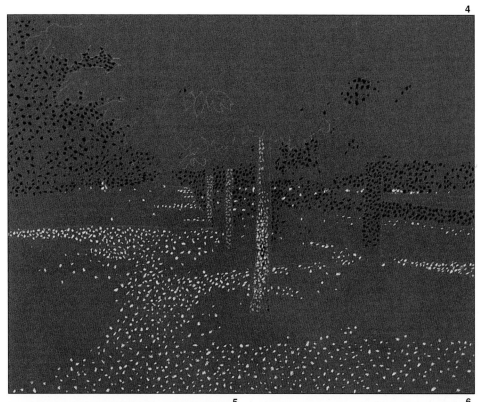

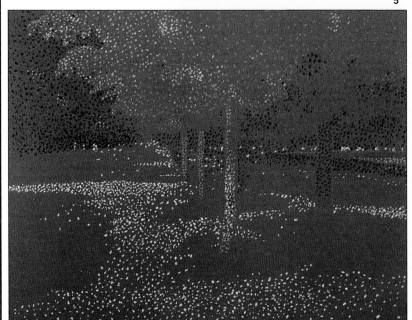

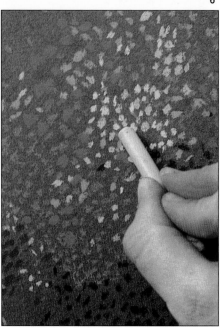

5 The artist starts to dot in the tones of the trees, using a variety of different greens. Those in the foreground are given a light tone to suggest sunlight playing on the leaves, while some blue is added to the dark green in the background to increase a sense of recession.

6 The general shape of the trees and their foliage is now in place and the artist concentrates on working on the trees in more detail.

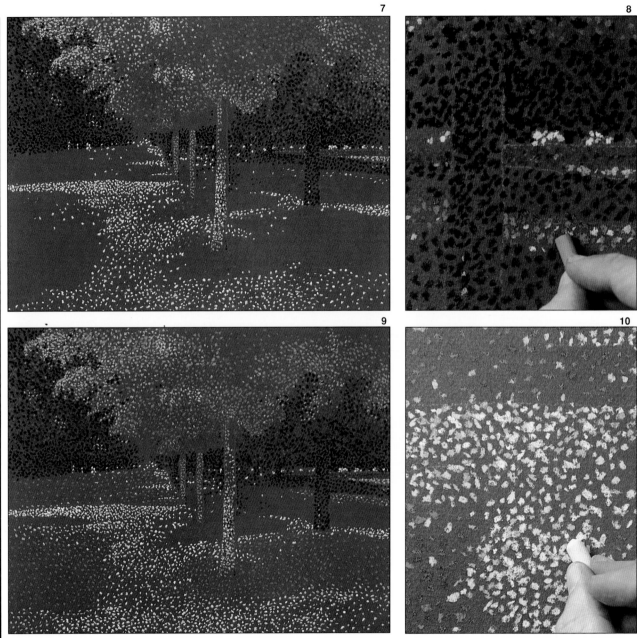

7 This close-up photograph shows how the dots of colour are applied randomly with the end of the pastel to build up areas of light and dark foliage and to give general shape to the tree. From a distance the leaves are beginning to look as if they are about to stir in a gentle breeze.

8 A bright band of blue is dotted in to the middle foreground. This also helps to take the eye down the line of trees into the distance. This mixture of tones makes the blue appear very intense and vibrant.

9 The artist starts filling in some of the foreground with blue. This ties the areas of light and shadow together, and the ground begins to show the effect of dappled sunlight.

10 More dots of pale ochre are added to the foreground to increase the intensity. Notice that much of the colour of the support shows through, but this provides a further colour and depth in the picture.

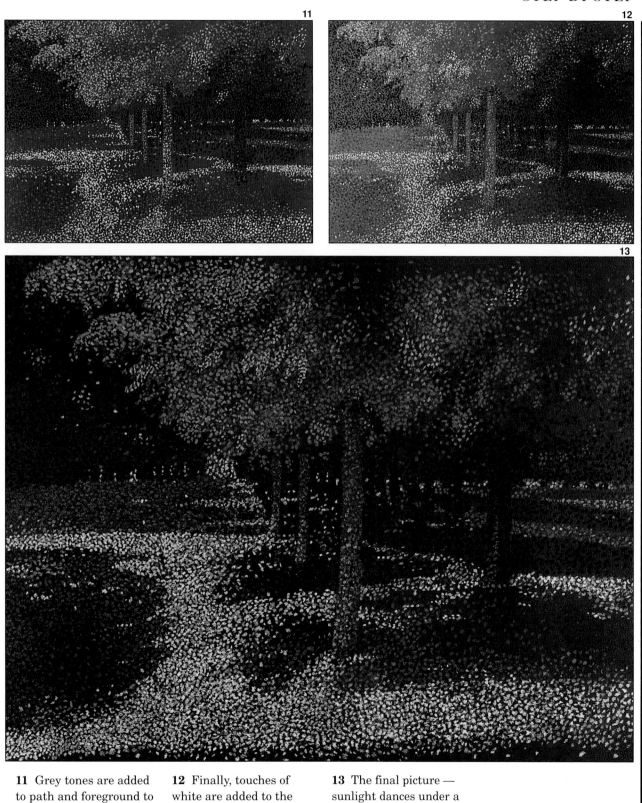

11 Grey tones are added to path and foreground to build up texture in this area of the picture.

12 Finally, touches of white are added to the light areas. These define the edges of the shadows.

13 The final picture — sunlight dances under a cool canopy of trees.

Venetian waterfront

STEP BY STEP

For the artist water is an ever-changing subject with infinite moods and colours, and its inclusion in any painting can have a decided impact. When it forms the main subject of a picture it can provide a very strong image, allowing you to use your imagination to the full and express yourself in a variety of techniques.

The waterfront at Venice must be one of the most painted and photographed subjects in the world, but this painting evokes an atmosphere that seems much removed from the crowded city so beloved of tourists. The gondolas are empty and tied up and the other side of the water seems a world away. It is an open image with a tremendous feeling of space. The water mirrors the sky and the dominant blues, greys and greens have been skilfully blended together with a torchon to create a cold, misty atmosphere.

Colours
Cool Grey 6
Intense Black
Prussian Blue 3
Green Grey 6

Coeruleum Blue 2 and 0
Silver White
Lizard Green 8
Hooker's Green 8

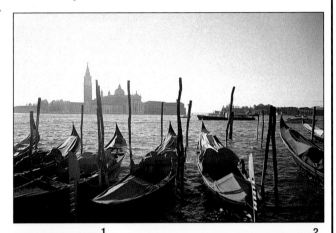

1

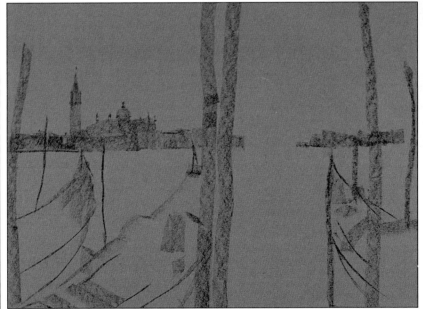

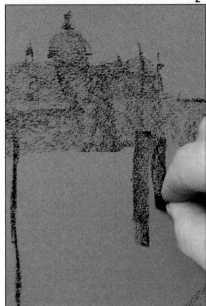

2

1 The artist draws in the subject in black, using the side of the pastel to block in the basic shapes.

2 This close-up shows the loose, open look produced by laying colour with the side of the pastel. A certain amount of atmosphere is introduced from the outset.

3 Thinner, sharper elements are drawn into the picture using the end of the black pastel.

4 With the basic outlines established, the artist now sets to work on the sky, placing a layer of very pale blue over the whole area. He uses the side of the pastel in broad, sweeping strokes and the pigment overlaps unevenly, building up texture.

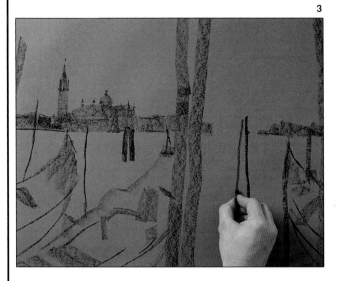

3

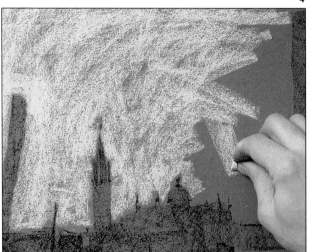

4

5

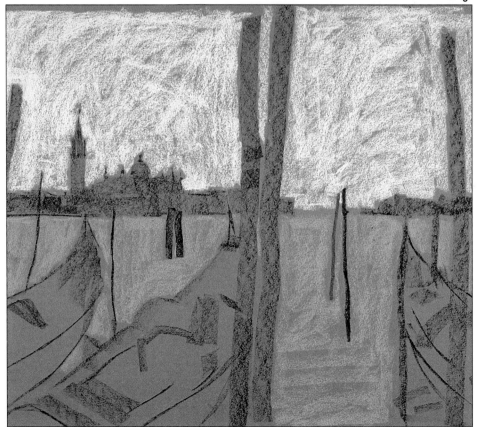

5 The sky is now in place, and the next stage is to lay colour on the sea. The blue ground will provide added depth, and already helps the artist to visualize the sort of mood he wants to express.

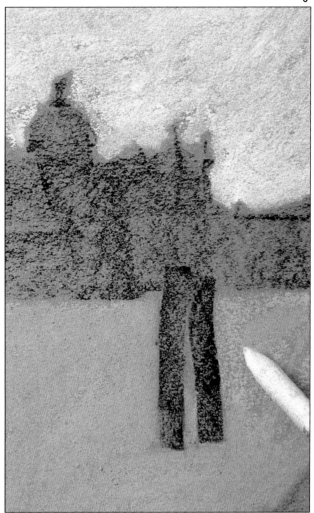

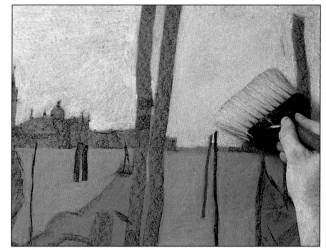

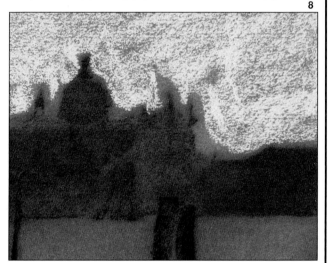

6 For the sea the artist uses a tint that is a little darker than the one used for the sky. He blends the pigment in using a torchon to produce a smooth texture, and sprays this area lightly with fixative to protect it.

7 To remove some of the pigment from the sky and to even out the texture, a large brush is used. Any powdery pigment that falls on the rest of the painting can be blown away.

8 When the sky texture is finished it, too, is given a light spray of fixative. A little of the powdery pigment may adhere to the area of the buildings, but this helps to emphasize their misty look across the water.

9 The sky and sea now look very smooth after blending with the torchon and brush. To firm up the various elements of the painting the outlines of the boats and poles are redrawn in black.

10 The artist decides to add more texture to the sky to give the impression of cloud cover and lays on another coating of blue, again using the side of the pastel in broad, random strokes. He then adds some colour to the boats in the foreground.

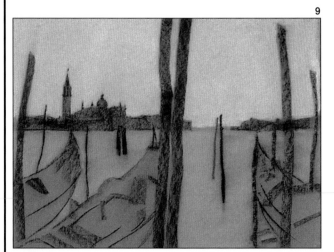

9

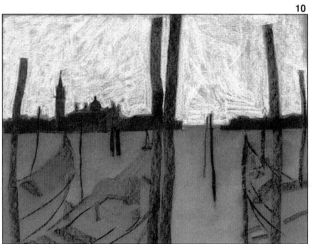

10

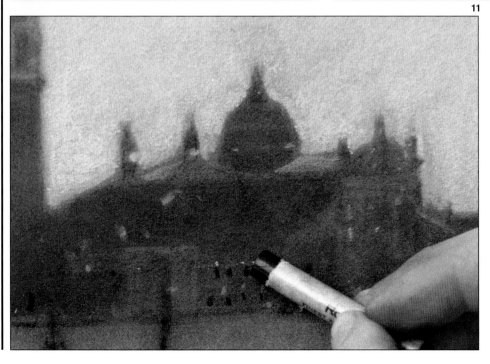

11

11 Across the water the buildings take on a blurred look as they are worked on in greys and greens. Tiny details are added in black with the end of the pastel.

VENETIAN WATERFRONT

12 To give more intensity and form to the colours on the gondolas a soft layer of pigment is put in, with darker areas denoting shadow and shape. A little green colour is added to the water in the foreground and dark shadow near the boats to create depth.

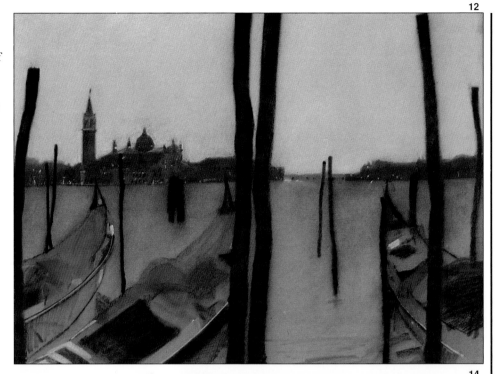

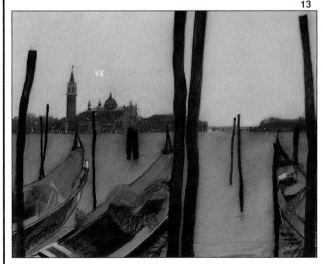

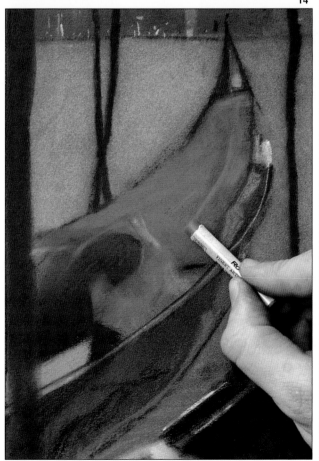

13 A further layer of undercolour is added to the gondolas.

14 Top colour is then painted onto the gondolas using the end of the pastel. Although they are from the cool end of the spectrum, the colours mix to produce vibrant tones that contrast with the cold surrounding water.

15 Dark green ripples are added to the water in front of the short mooring poles where the water is likely to break and eddy.

16 The artist then works areas of grey shadow into the gondola on the right to give it form.

17 Further areas of dark green ripples are drawn around the poles and boats to give movement and depth to the water.

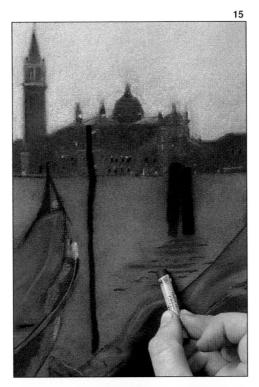

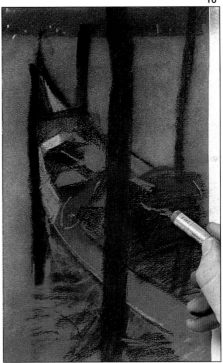

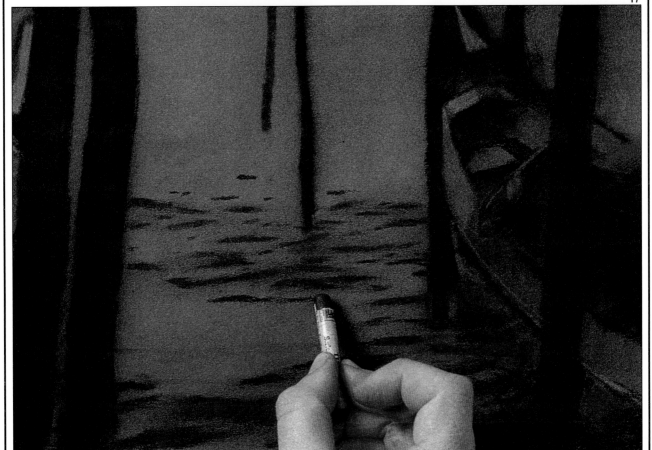

VENETIAN WATERFRONT

18 The painting is nearly complete, but there is still some work to be done to the water to increase the feeling of recession and space.

19 To widen out the expanse of water small dots of white are placed across the width of the picture and stretching right out to the horizon.

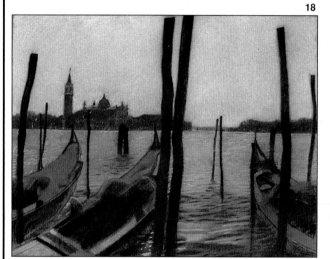

18

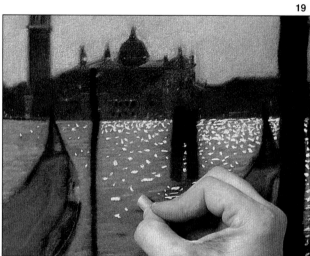

19

20 Pale blue dots are then interspersed among the white, and darker blue streaks are dabbed into the foreground water where the artist will blend them with the dark green ripples.

20

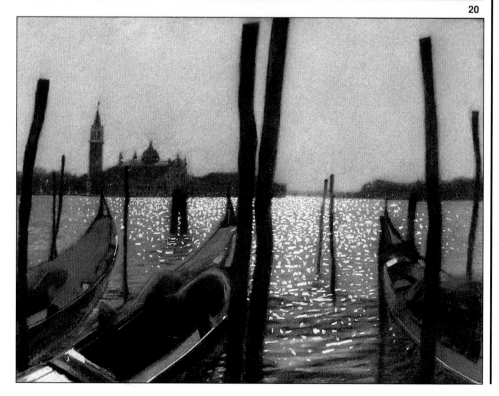

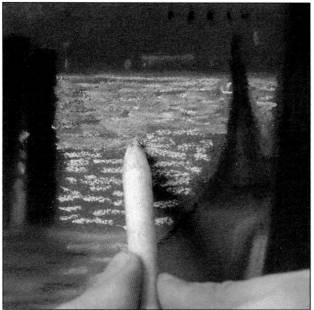

21 To achieve a smooth, shimmering finish to the water the artist blends and mixes the dots of colour with a torchon.

22 The painting is finished. The artist has captured a feeling of space, mood and subtle movement using only a limited palette of blues, greys and greens.

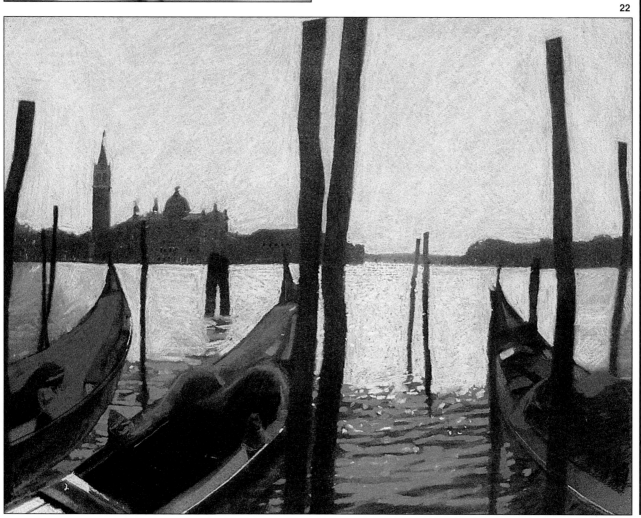

Chapter 8

Townscapes

So many of us live and work in towns and cities, yet we invariably fail to see what excellent subjects they make for paintings. Perhaps we paint the occasional scene on holiday when we expect to notice the unusual and want to record our own visual impressions, but there is also a lot of material available locally if we look for it.

Pastels are easily transportable and it is a simple matter to take them along to a park bench at lunch time, or to spend half an hour or so painting the view from an office window. Long bus and train journeys also provide ample opportunity for some interesting scenes and skylines, and many buildings have attractive architectural details which can form the basis of a creative picture.

The approach to painting a townscape is slightly different to that needed for landscape. For a start, you are not so likely to be viewing your subject from a long distance away. You may well be looking up at it if it is a tall building, or only able to see part of it, so a well planned composition will be essential.

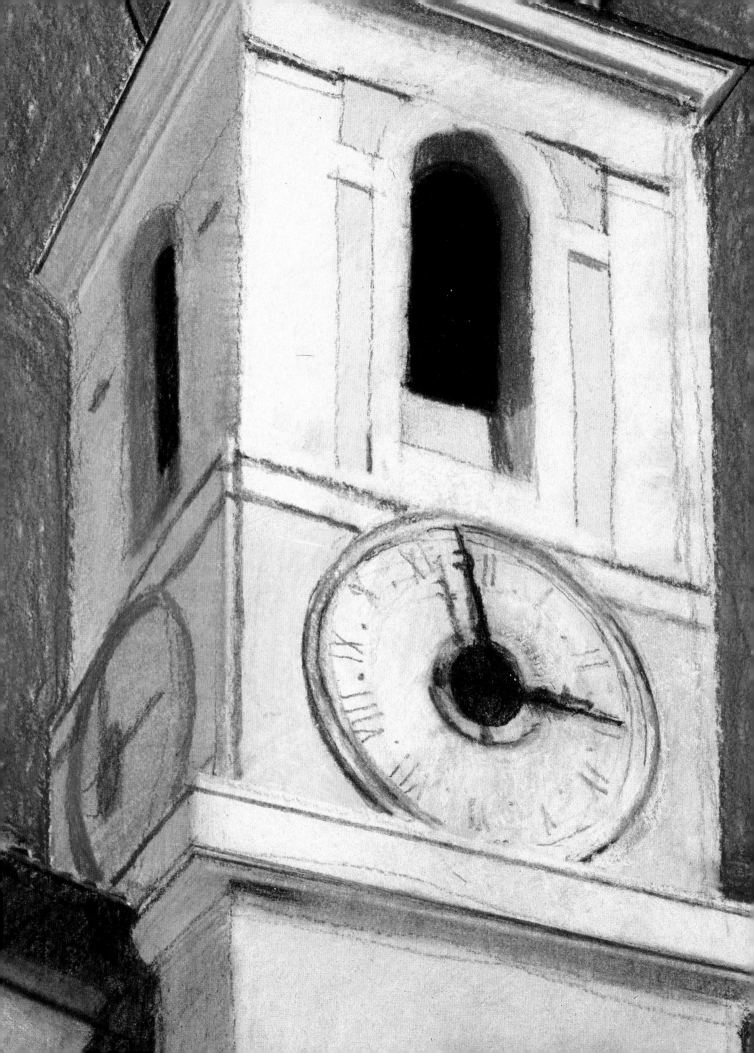

Lloyd's building at night

STEP BY STEP

The famous Lloyd's building in London seems a rather daunting subject for a painting. Not only is it so huge that you can only look up at it, but there seem to be so many details to include that are impossible to study at close range. Just where do you start?

The way to approach a subject like this is to concentrate on getting the overall shape and proportions of the building correct and to provide an approximation of its various parts. Here the artist has taken a viewpoint at some distance from the building and drawn it in perspective so that it seems to soar into the sky. He has drawn it much as the architect must have planned it, by first putting in a framework before gradually adding the different elements piece by piece.

Yet the mood of the painting conveys much of the life of the building and what happens in it. By choosing to illustrate it at night with lights blazing the artist communicates something of the atmosphere of an institution that is always active. The choice of a dark support is ideal since it throws the building into relief against the night sky.

Colours
Blue 144, 146 and 148
Green 154, 161 and 171
Orange 113
Yellow 108
Violet 138
White

1

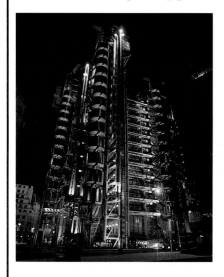

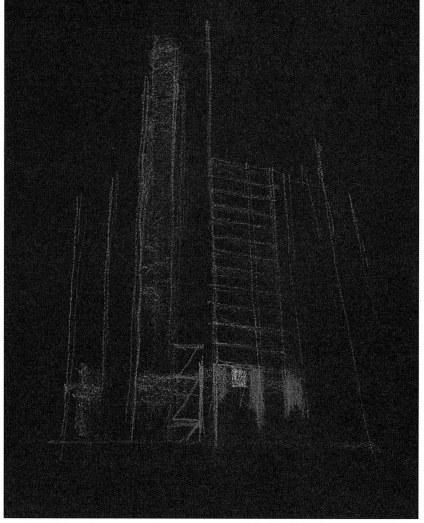

1 The artist starts work by putting in the vertical lines and shapes of the building, making sure that the perspective is correct.

2 Some of the horizontal window areas and the areas that will contain the 'balcony' towers are lightly shaded, while more detail is added to the ground floor. Throughout, the colours used are rather harsh, indicative of the artificial lighting and typical materials of a large office building.

3 When drawing a building of this size it is virtually impossible to put in precise detail and so the artist encircles areas near the entrance which he will later build up in an impressionistic manner.

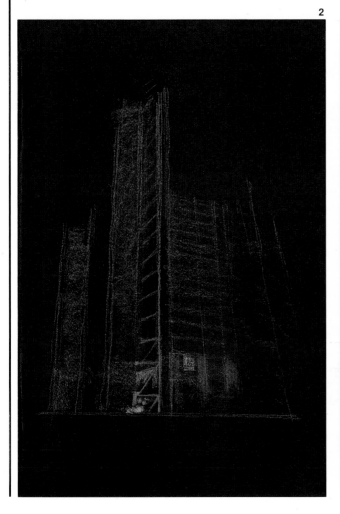

2

3

4

5

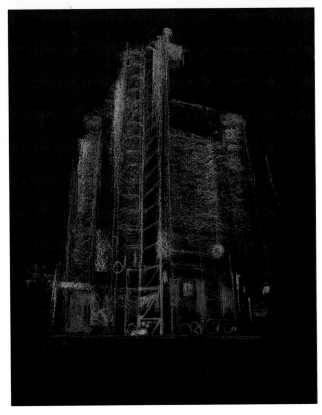

4 The general feel of the drawing is sketchy and the dark support provides a great deal of the shadow and substance of the building.

5 The main areas of the building have been denoted in line or shaded in. The shading is starting to give the building a solid look although the main structural detail has still to be worked on, and the areas of orange for the glare of sodium streetlamps are beginning to set the night-time scene.

6 Structural detail is added to the building. The towers are given their green 'balconies' which make such a feature, and the window frames are outlined in blue.

6

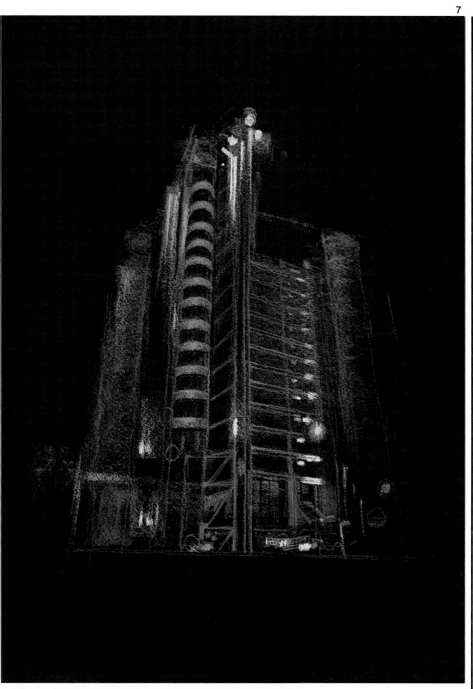

7

7 The artist starts to add spots of reflected light and highlights on to the glass windows and the building begins to come alive.

LLOYD'S AT NIGHT

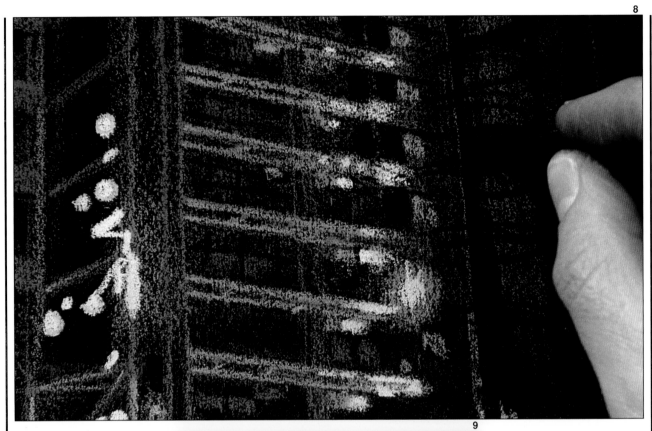

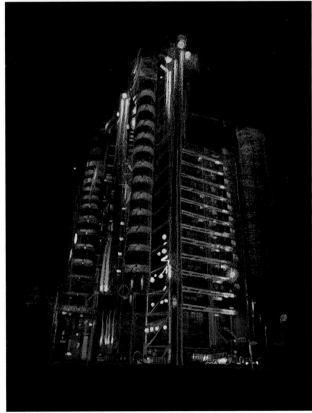

8 The darker areas of the balconies are defined in black and here the artist is adding the spiral shape to the right-hand tower. Further areas of colour are shaded in squares into the window frames to give more substance to the glass.

9 Impressionistic detail is added to the entrance to show how far the viewer is from the building and to emphasize its size. The tower on the right still needs to be completed.

10 The finished painting looks much more complicated to draw than is the case, and simple techniques have been used throughout to produce an architectural picture with a great deal of atmosphere.

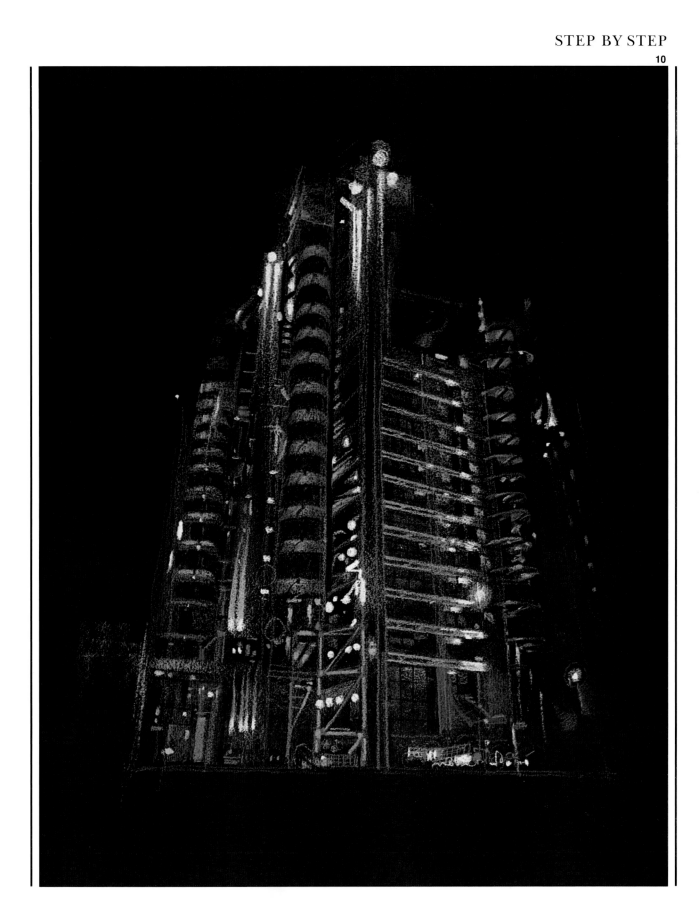

French church

STEP BY STEP

Many small towns have a wealth of interesting features that the artist can put to good effect. The simple bell tower of this church contrasts with the more ornate architecture of its façade and by painting the building from the side the artist can outline both shapes in silhouette against the sky.

The painting immediately evokes the bright light and hot sun of the Mediterranean, produced by juxtaposing flat areas of complementary colours. The soft yellow of the tower is balanced by the bright blue cloudless sky. Each colour is confined within a shape — the blue sky, the yellow tower, grey walls and green trees. This precision of line gives the painting a sense of immediacy usually associated with a screen print.

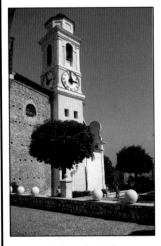

Colours
Coeruleum Blue 4
White
Intense Black
Green Grey 6 and 4
Cool Grey 4
Yellow Ochre 2
Lemon Yellow 2
Lizard Green 8

1 The basic outlines for the church and tree are drawn in, including the details of windows and the lamp.

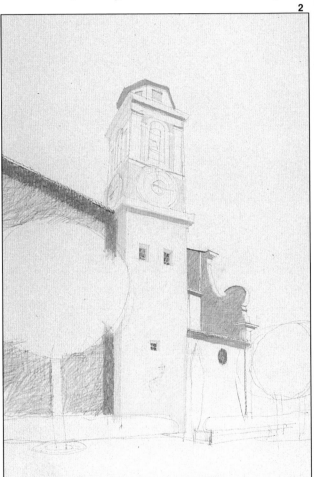

2 The ochre colour of the tower is gently blended in with a little white with a torchon, using a darker tone for the areas in shadow such as its side and the window reveals, and the windows are blocked in with black. A slightly looser technique in grey is used for the back of the façade to create a little texture, and loose hatching in warm tones is used for the wall in the foreground.

3 Using white, the artist cross-hatches the brown on the walls. This mixes the colours and produces a soft textured look. He then gently hatches a soft pale greenish grey tone to the wall on the right.

4 The bright blue sky is laid down, using pastel with a torchon to build up the depth of tone.

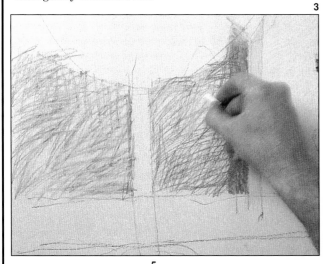

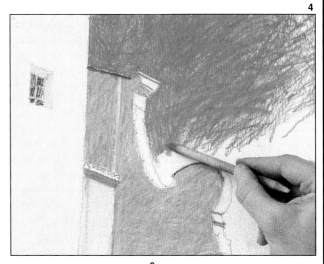

5 With the sky completed, the artist can now concentrate on the trees and details of the building.

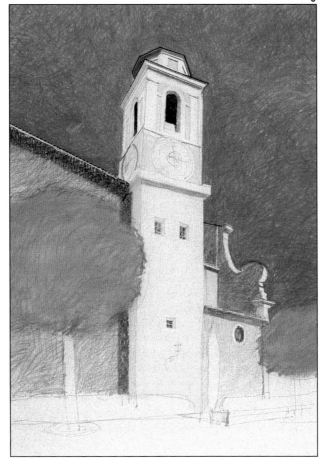

6 Green pastel is added to the rounded shapes of the trees, and the colour is softly blended. The outlines of the tower are delineated in black and the belfry openings shaded in. A dotted black line suggests the tiled roof line on the left.

FRENCH CHURCH

7 To obtain a precise line for the shading at the top of the wall the artist works against the edge of a wooden rule.

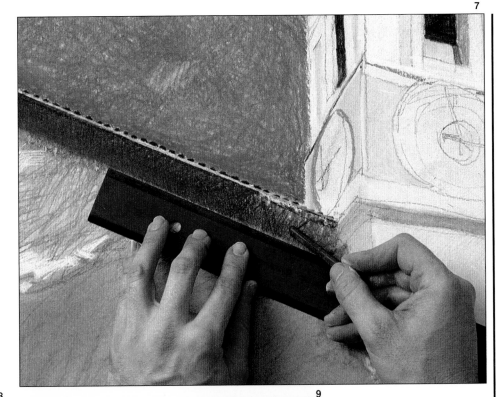

8 The wall on the right is now completed by mixing over a layer of white to give the textured effect of white stucco. Shading is added to the reveal of the round window. Notice that perspective causes this window to appear as an ellipse.

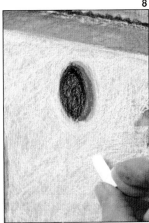

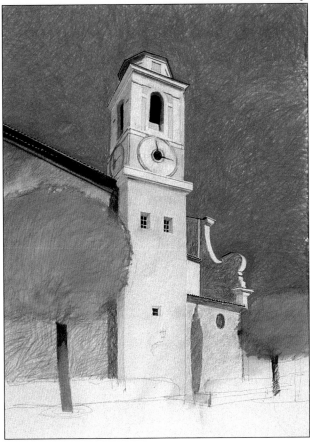

9 Shading is added to the clock to define its shape and depth. The tree trunks are filled in and blended at the bottom to denote the shadow cast by the foliage, and undercolour is laid down for the shrub by the wall.

10

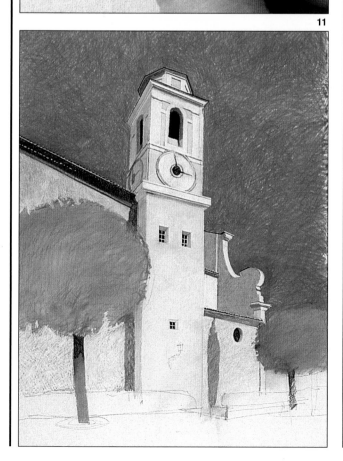

10 The window frames are picked out in white and the panes of glass are strengthened in black. A little grey shading is added to the window reveals.

11 The windows now show up as clear architectural features of the tower. The artist paints in the details of the clock face.

12 A further layer of dark green colour is added to the shrub by the wall, keeping the edges soft to convey the way the foliage grows.

11

12

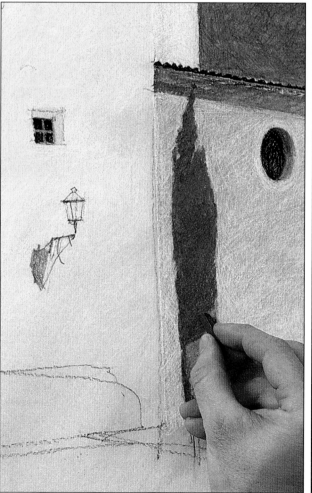

FRENCH CHURCH

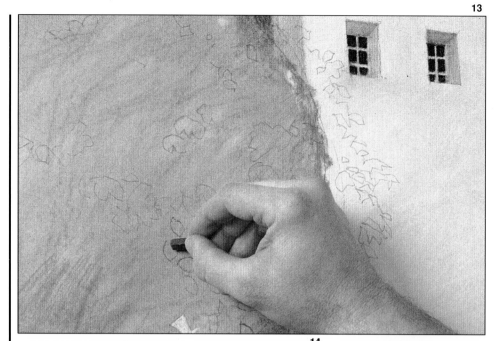

13 Attention now turns to the foliage of the trees. The artist outlines random areas of leaves in a slightly darker green than that used for the blended flat colour.

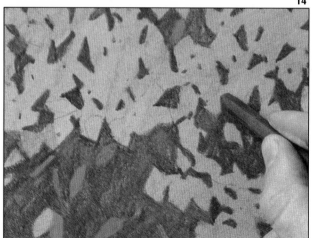

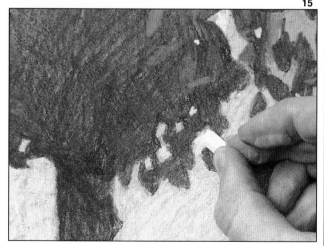

14 Impressionistic dashes of varying tones of green are layered on to the trees to illustrate leaves. A lighter yellow green is used for the top layers of foliage to represent new growth.

15 Odd dashes of white are introduced at the edges of the foliage to break up the harshness of line and give some movement to the leaves.

16 Finally, detail is worked into the foreground of the picture. A hedge and pavement are added, the trees are firmly planted in a circle of earth and the lamp on the bell tower is firmly drawn in.

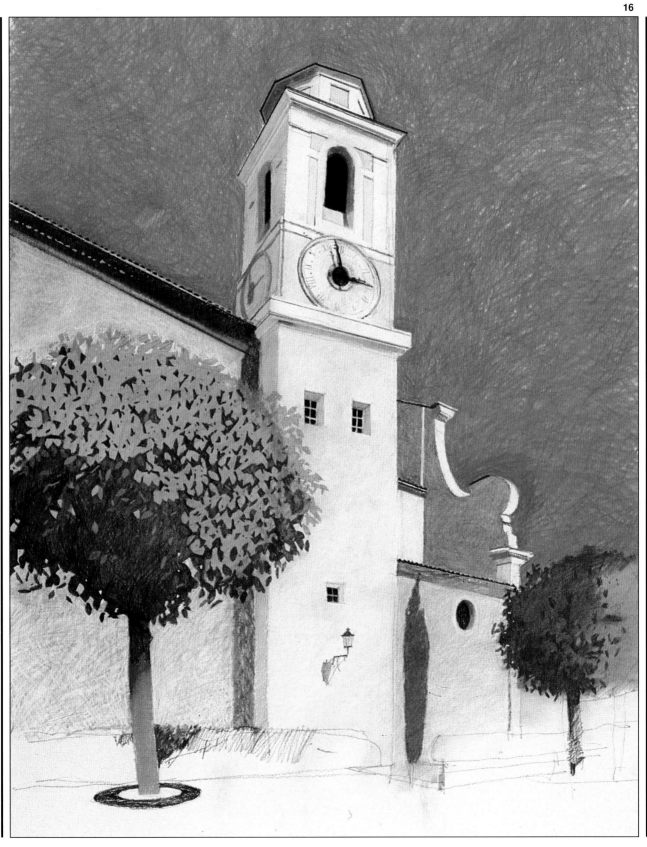

Chapter 9

Animals

Painting animals can be an absolute joy or cause total frustration. The problem is that no sooner you think they are perfectly posed than they move, fly away or turn their heads. There is no real solution other than adapting your approach to the whims of your subject. It is best to make the most of the nature of the animal, conveying its strength, speed, movement, bright colours, markings, furriness or whatever it is that makes that animal typical of its species and yet an individual.

Capturing the essence of an animal is easier if you spend some time just watching it and making sketches before deciding on your final painting. Examine its characteristic features such as the shape and size of its head, ears, beak, paws or hooves. Observe the way its muscles move when it walks or runs, or how it holds its wings when it flies, and jot down any notes on colouring.

Animals present a variety of different coverings. If at first you are not entirely confident in painting fur, feather or skin try an impressionistic technique. You will soon develop the skills required to put in any extra detail.

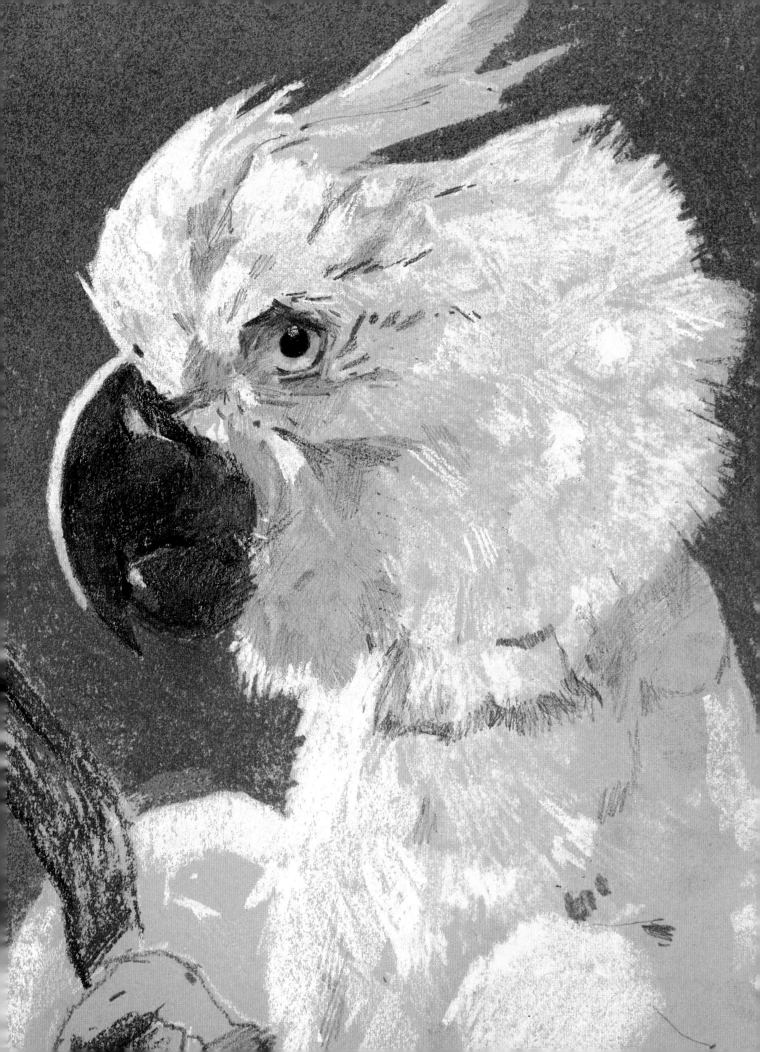

Cockatoo

STEP BY STEP

Birds are notoriously difficult to capture on paper. Even when they are not flying they make sudden quick movements, cocking their heads and fluttering their wings as they change position, so it is as well to work out a rough composition from the outset. You can then make a number of detailed sketches of the head, bill, eyes, claws, wings and feathers which will give you the confidence to plan your picture properly.

The magnificent plumed crest of the cockatoo shown below is probably its most distinctive feature, along with its hooked bill, so in this painting the artist has put the visual emphasis on the bird's head. The shape of its powerful wings and massive claws are also strongly defined.

Instead of trying to reproduce the details of the feathers exactly a loose style is used to suggest the texture of the soft downy head and crest. A skilful use of mixed media with graphite and pencil gives depth and shape around the neck and eye.

Colours
Silver White
Yellow Ochre 6 and 0
Lemon Yellow 6
Burnt Umber 6
Intense Black
Cool Grey 4

1 The artist chooses a support in a pale neutral tone that will match in well with the colouring of the bird's plumage and draws in the outline of the cockatoo in white.

2 The bird immediately comes to life with its black bill hatched in and the pupil and orange iris of its eye added.

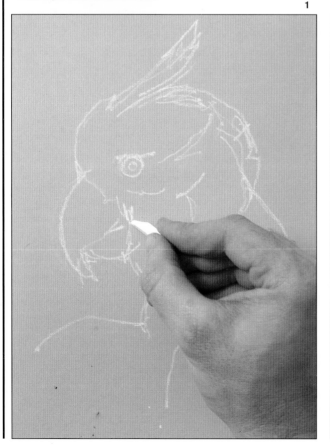

1

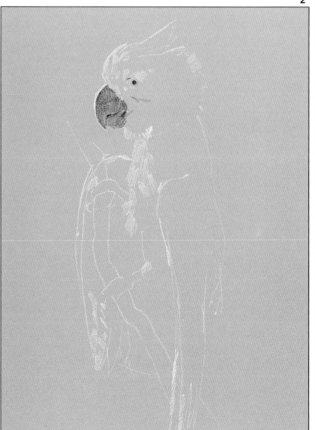

2

110

3

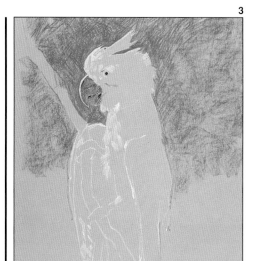

5

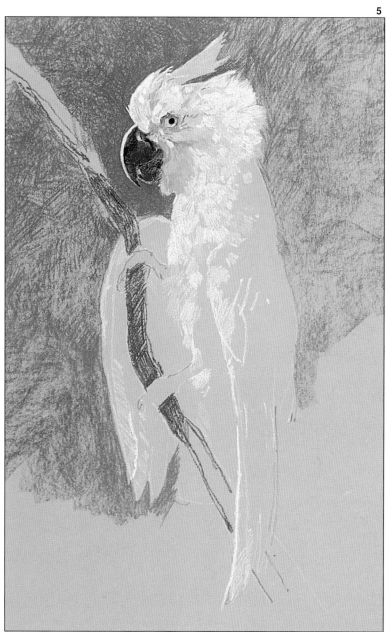

4

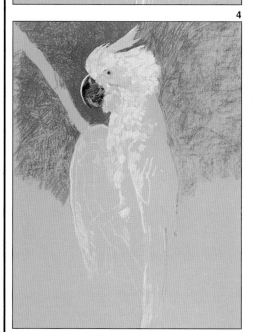

3 Areas of feather are put in by using the white pastel on its side in short, blunt strokes. A line of white outlining the bill throws it into relief and gives it spatial dimension. The artist starts to add the grey background, hatching with the end of the pastel in the area around the head and laying the colour down with the side of the pastel at the outer edges.

4 Yellow is added to the crest and to the area around the eye, including the bottom curve of the iris. It is also laid down inside the wing, again using the pastel on its side to block in the impression of feathers.

5 Grey shadow is added to the downy feathers around the bill, and the indentation around the eye is defined. The artist uses brown to hatch in the branch so that the cockatoo does not appear to be floating in mid air.

COCKATOO

6 Graphite is used for the claws. The slightly shiny look of this medium suits their horny texture.

7 The artist uses a sharp pencil for details of shadows and wrinkles on the tiny area of skin around the eye. A white highlight is added to the pupil.

6

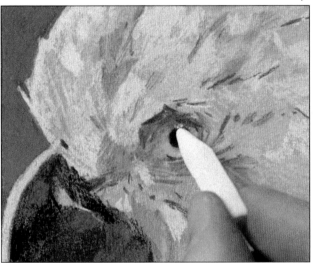

7

8

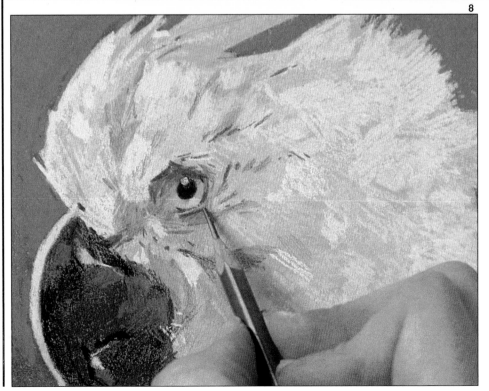

8 The artist continues to work on the area of the skin around the eye. Some of the pencil strokes may soften the highlight so an extra dab of white pastel is carefully applied. Highlights in the eyes are extremely important when painting any live creature and without them the pupils look dead.

9 To give the impression of the depth of the soft plumage on the head as well as the shape of the head, the line of the neck is shaded in with pencil.

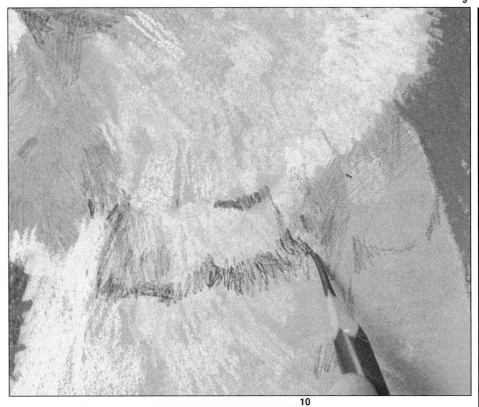

9

10

10 Further lines of feathers are drawn in with the end of a white pastel and areas of plumage depicted in broad strokes by using the pastel on its side. The colour of the support shows through a great deal, some areas not having any pastel on them at all, and gives further tonal value to the body of the cockatoo.

COCKATOO

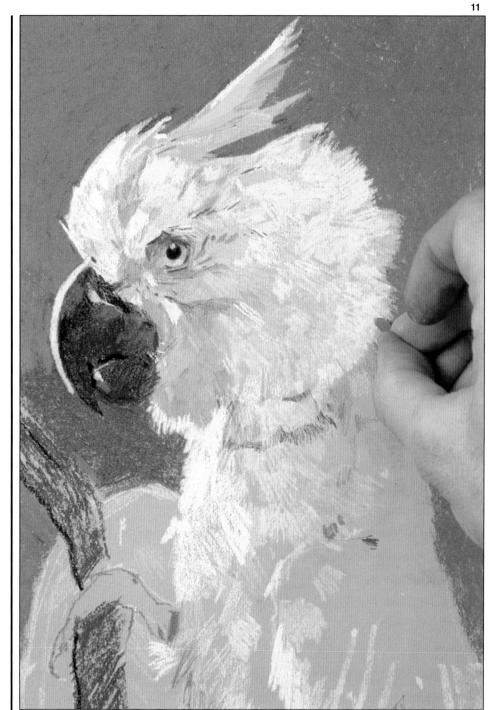

12 The long tail feathers are defined in white, and the line of the wing at rest is strengthened with a broad band of white pastel. To emphasize the silhouette of the bird the background is given a further layer of grey.

13 In the final painting the cockatoo's head with its wonderful crest stands out against its rather sombre background. By concentrating the detail here but carefully defining other areas, the eye takes in all the elements that contribute to the sheer power and beauty of this creature.

11 To distinguish the individual feathers and give them their characteristic spiky look at the edges, the artist separates them with short fine lines in graphite.

Again this medium is ideal here as its slight shine picks up the light as it falls on the painting, giving a little movement to the head of the cockatoo.

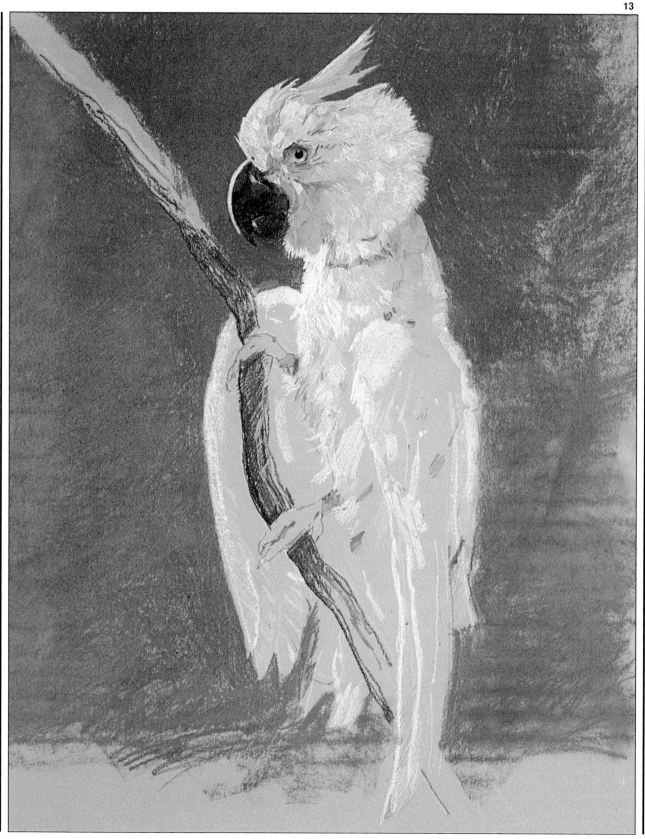

Cowboy

STEP BY STEP

This imaginative painting of a rodeo scene is all about movement. As the horse bucks to try to unseat its rider so the cowboy leans back in the saddle to balance, and the artist seems to capture a split second in time.

The success of this painting lies for the main part in the accuracy with which the horse is depicted. The animal's arched back and stiff forelegs as it leaps into the air to kick out its hind legs are the typical actions of a bucking horse. Its nostrils flare with the effort and strength of its task. All this is the result of careful observation and numerous sketch studies over a period of time.

Technique and colour work hand in hand. The anger of the horse is shown in its red eye and nostril. An orange blur around its body radiates the intense heat of exertion, and speed whips away behind its tail. Amidst all this the cowboy, dressed in pale blue, keeps his hat and appears balanced and composed.

Colours

Orange 113	Violet 139
Yellow 102	Pink 131 and 132
Red 118	Yellow Ochre 183
Green 158	Brown 180
Blue 143 and 146	White

1 The artist chooses a warm-coloured support and outlines the horse and cowboy in orange. He uses the side of the pastel to block in the curves of the horse's flanks.

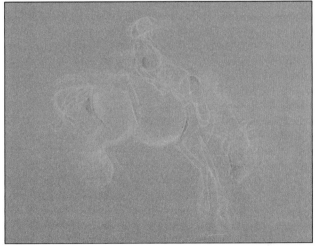

2 Areas of dark blue shadow are placed under the horse's head and tail and under the strap holding the saddle blanket. The cowboy's arm and knee are also shaded in blue to help build form.

3 The orange outline is strengthened in places by the addition of a red one. This is in the areas where action is most intense — around the horse's head, mane and hind quarters and around the cowboy as he is jerked violently about. Blurred orange behind the horse's flanks and cowboy's hat implies speed.

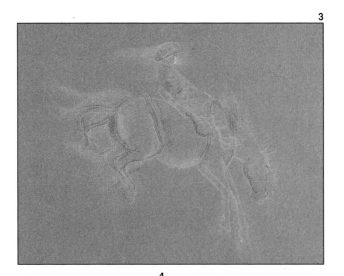

4 Blue green undercolour is applied to the horse's body with the side of the pastel. This enables the artist to achieve even areas of shading. Layers of other colour will be mixed on top to create brown tones for the horse.

5 Areas of highlight are added to the cowboy's hat, apron and boot with the end of a white pastel.

117

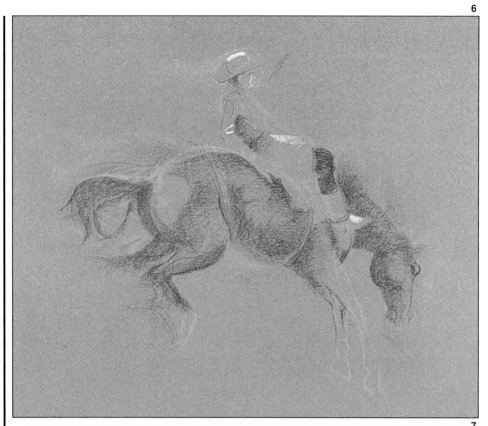

6 The painting is beginning to take shape. The horse's back arches in one continuous curve and the power of the hind legs is suggested.

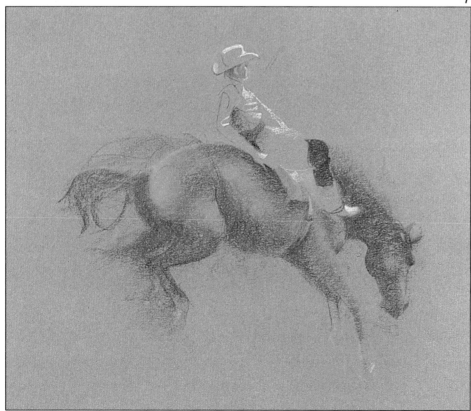

7 To make the deep brown tones of the horse's body the artist mixes red pastel with the existing blue green. Areas of the support are left blank to give tone and shape to the horse's flanks.

8

10

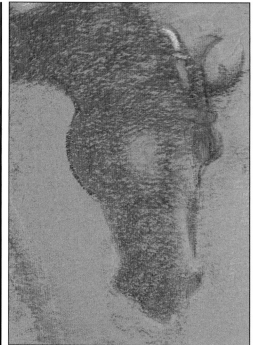

9

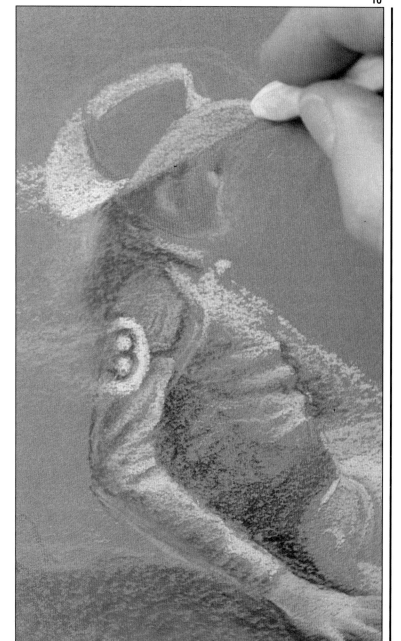

8 This detail of the horse's head shows how the layers of blue green and red shading mix to give brown textured tones. Red is added to the horse's eye and nostril.

9 The artist now starts to add colour to the cowboy. Here he is using green as undercolour to the shirt.

10 Pale blue is scumbled over the shirt, and other details of shading are put in. The upturned brim is given a tone several shades darker than those used for the hat. The fingers of the hand are defined quite carefully with tone since they are at the forefront of the picture, while the cowboy's face is handled with a much more impressionistic style.

COWBOY

11 A close look at the cowboy's face and shirt shows a careful use of layered colours and odd dashes of complementary colour to build up the detail. The blurred features on his face and blurred edges to the left side of his hat, scarf and arm show that he is moving through the air with a great deal of speed.

12 Detailed shading has also been added to the cowboy's apron and leg. The toe and front of his boot are highlighted in white and a great deal of the colour of the boot is formed by areas of the support which have not been coloured.

13

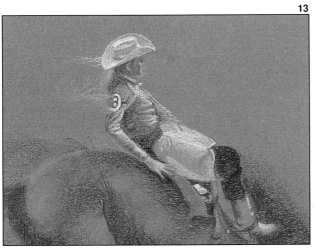

13 Lines of white across the cowboy's shirt show him twisting slightly as he tries to keep his seat on the horse. His calm pose, emphasized by the light colours of his clothes, is in sharp contrast to the fury of the horse.

14 From a distance soft, loose layers of colours blend with the colour of the support to give a surprising amount of detail in the final painting.

14

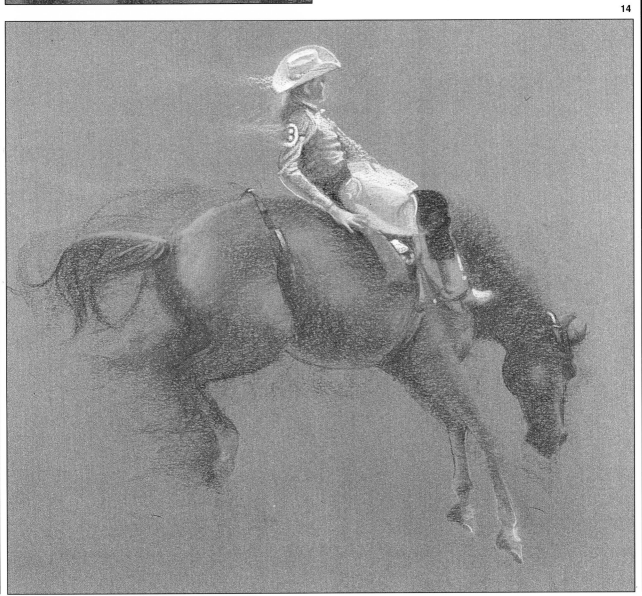

Chapter 10

The human figure

Many of the great artists made numerous life studies, for the simple reason that the human figure brings into practice all the elements of art theory.

No matter how similar we may seem to be, each person has their own shape and form, which means that light falls on our bodies in a slightly different way and casts shadows that are distinctive to us. The proportions of one part of the body to another may not be exactly to the norm. Our varying skeletons and musculature give us each a particular way of moving, while our facial bone structure ensures

features that distinguish us from anyone else and make us individuals.

Flesh tones call for the subtle use of combinations of colours applied delicately to suggest the soft texture of skin. Again, each person has their own individual colouring of skin, eyes and hair. A bonus in painting from a live model is that you can choose the sort of pose you want to reproduce. Remember, though, that a position must be held for some time, so make sure that your model is fairly comfortable and allow time for a break every so often.

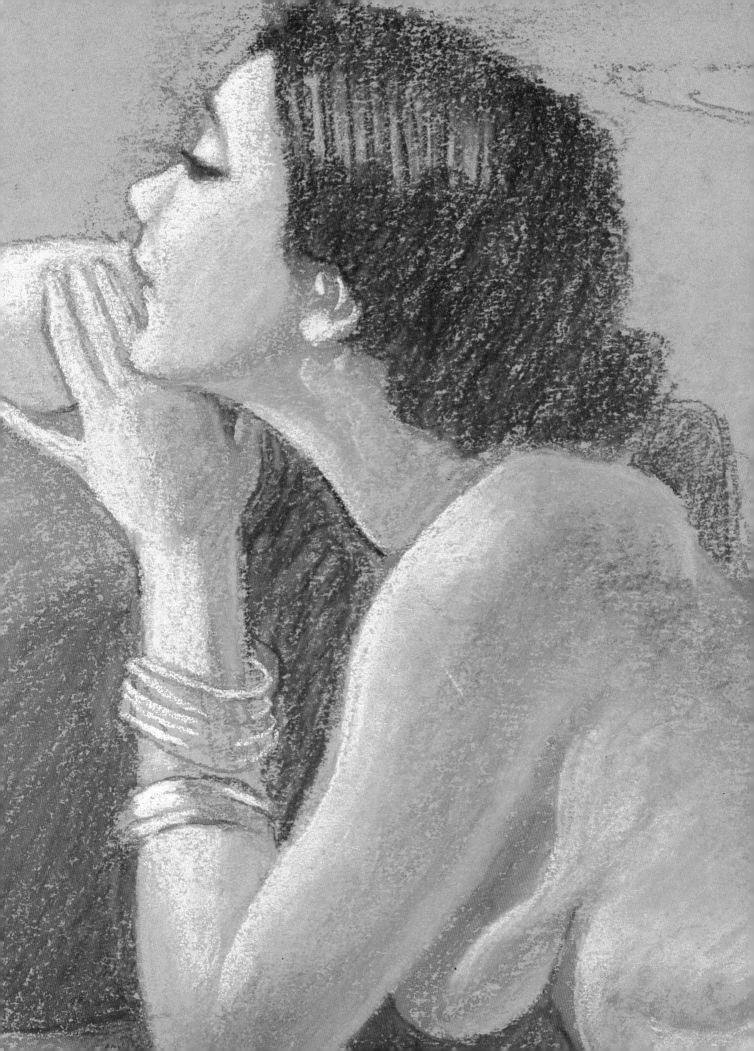

Portrait of a man

STEP BY STEP

Nearly all of us at some time want to paint a portrait, whether of friends or family or ourselves. As well as wishing to produce a good likeness in terms of physical features we usually also want to portray some particular aspects of the subject's character and personality.

Painting a portrait brings into play a number of considerations. You must decide whether the subject should be depicted full length, or just head and shoulders, full face, side face or three-quarter view. Should they be wearing a particular item of clothing, such as a favourite sweater or hat? What sort of background is appropriate to the picture?

Lighting is important in portrait painting and here the artist has placed the light source in such a way that the left side of the subject's face is in fairly defined shadow. This gives the opportunity to paint the skin tones in small patches of colour as the light strikes the different planes, and to work on the texture of the sweater as it picks up the knitted stitches.

Colours
Poppy Red 8 and 1
Burnt Sienna 4 and 0
Prussian Blue 3
Burnt Umber 4 and 2
Yellow Ochre 2 and 0
Blue Grey 6
Cool Grey 4
Green Grey 1
Intense Black

1

1 As with nearly all subjects the first stage is to produce a line drawing of it outlining the various planes of the face.

2

2 The darker areas of shadow on the face are laid down in patches of brown, and some areas of warm skin tone delineated in red. Very dark areas, such as the hair and spectacles and shadow inside the collar, are added in black.

3 Lighter tones are now laid down to create form and shape around the folds of the face.

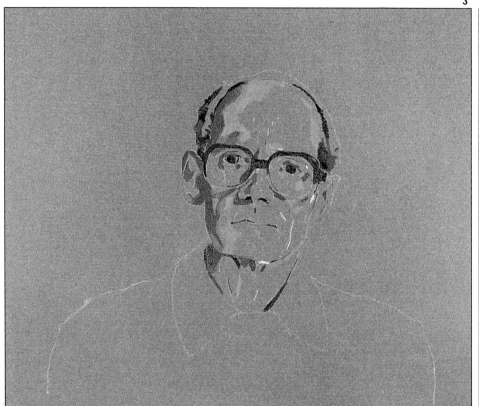

4 As the various areas of tone are added the artist blends them with a torchon. Notice that although the subject is wearing spectacles the pupils of his eyes still need white highlights. To show the reflective surface of the glass the artist adds a little white.

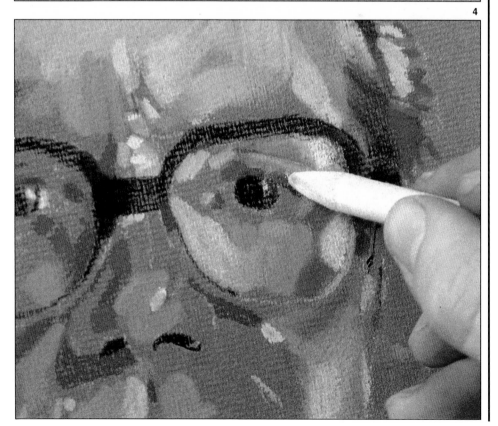

5 The areas of light and shadow are beginning to build up to give form and structure to the face. Colours for the left ear are blended.

6 Further areas of light are laid on the forehead and chin, and highlights placed on the nose, lips and left cheek. The skin around the eyes has areas of reflected light from the glass of the spectacles. A little fixative is sprayed onto the painting to protect it.

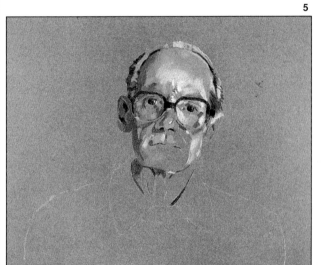

5

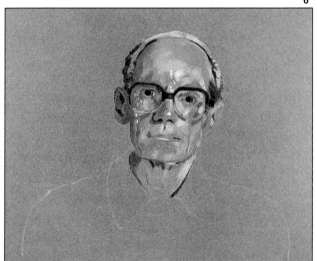

6

7

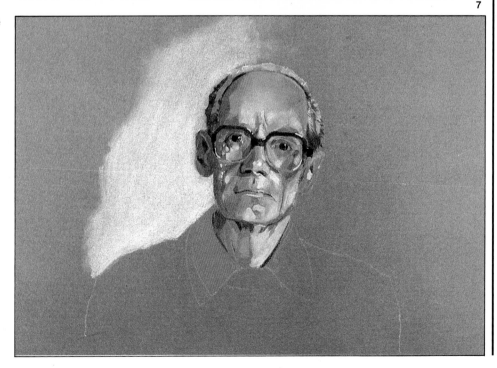

7 With the features of the face now painted in and the lines of wrinkles defined in brown, the artist starts scribbling in the background in white pastel. He also lays down flat colour to the red collar, using his finger to blend it.

8 Using the corner of the pastel dashes of pink are added to the skin around the eyes to give highlights and form to the wrinkles.

9 Again using the corner of the pastel, grey shadows are added to the eyelids, and small dots of colour to the irises to give depth.

10 The colours of the collar are laid in bright bands and immediately form a contrast to the subtle tones of the face. The white lines are added first, then the blue to finish off the edge.

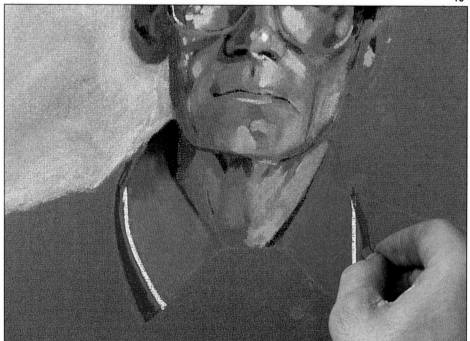

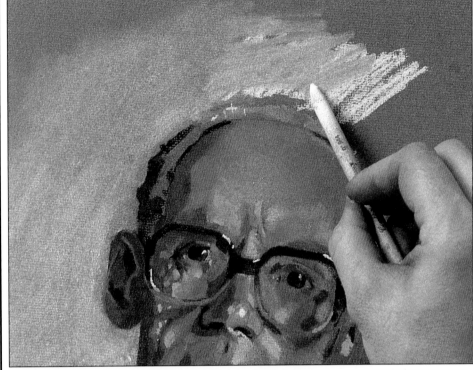

11 More white pastel is scribbled into the background and then blended in with the finger, creating a soft outline around the head and hair.

12 Pink is added to the lips. By spraying the pigment with a little fixative the tone darkens slightly so that a further stroke of pink acts as a lighter tint and gives form and depth.

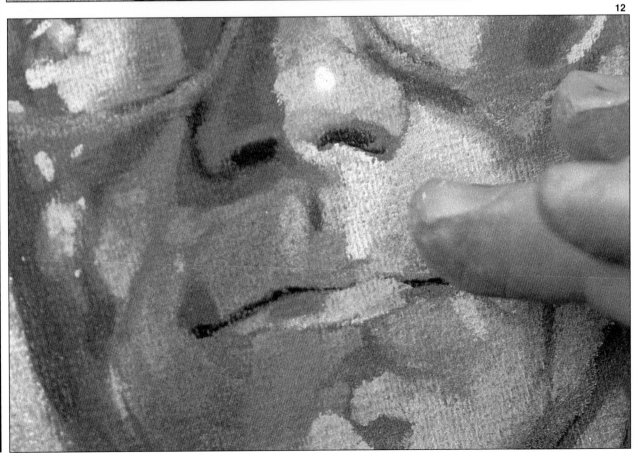

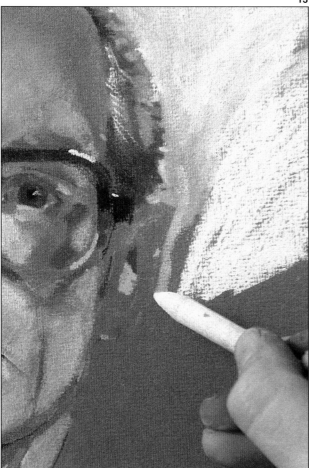

13 The artist continues adding white pastel to the background, and carefully blends it with a torchon around the ear.

14 Against the white background, areas of the face seem a little too light, so the artist covers these with a slightly darker tint to tone them down.

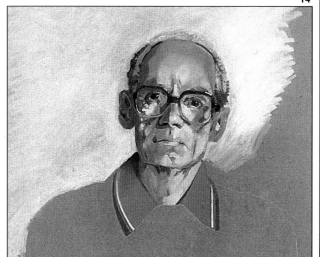

15 Grey is added for the shadow of the head against the wall and blended gently with the finger to soften the outline. Notice that the shadow is not completely round, as the light falls at an angle across the head.

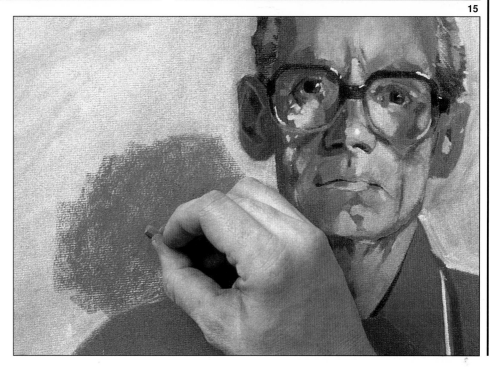

129

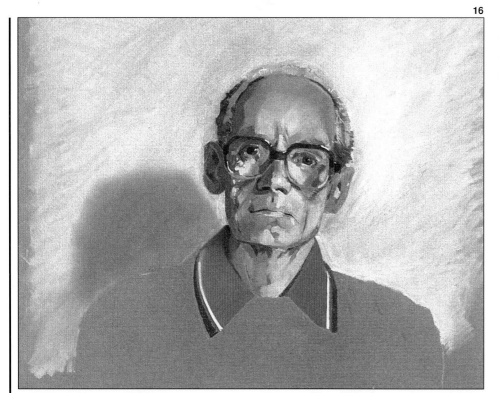

16 Now that the face and background are complete, the details of the sweater can be worked in.

17 To show the pattern made by the knitted stitches the colour of the support is used as a deeper tone. White pastel is applied and smoothed with a torchon. A little yellow is applied to the neck of the sweater for shading.

18 The pattern is further defined with a little black pastel in the indented areas to build up a regular pattern.

19 The finished portrait
has colour and character.
The artist has used a
number of techniques to
portray a variety of
textures, enabling the
personality of the subject
to come to the fore.

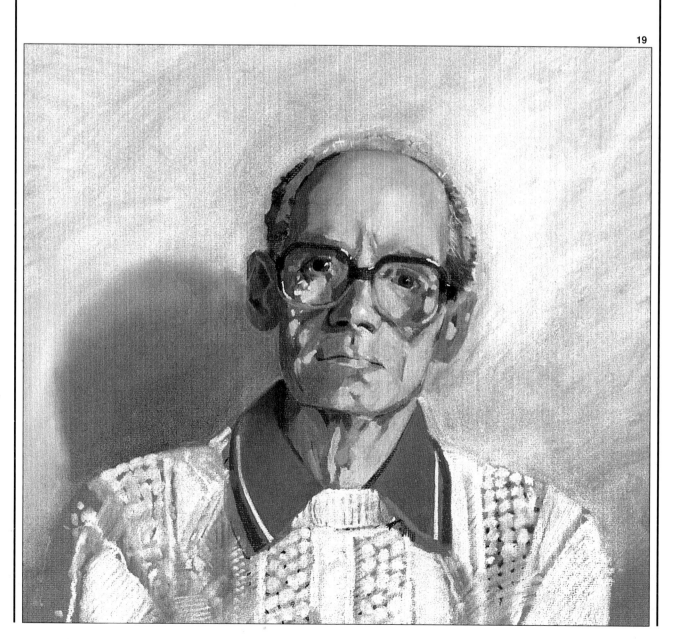

Female figure

STEP BY STEP

Painting a nude subject successfully requires meticulous planning, concentration and a great deal of observation.

A good knowledge of the general proportions of the human figure is essential so that you can think about depicting the shapes you see before you, and time spent making preliminary sketches will reap its reward. Before painting from a live model plan the type of pose you want to portray so that you will be fully prepared.

The pose chosen for this painting means that the upper body is slightly foreshortened and must be drawn in perspective. The light source is directed on to the model's face, hands and upper body so that her back and left leg are in shadow.

The artist has built up the form of the figure with soft shading, using a variety of techniques to portray the delicate texture of skin. By layering and blending a number of different colours and tones he has achieved warm and realistic flesh tones.

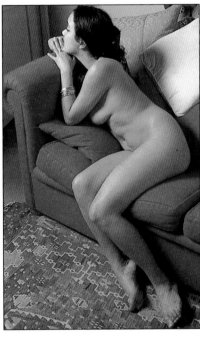

Colours
Red 118
Red Violet 128
Orange 113
Pink 130, 131 and 132
Yellow 102
Green 154 and 158
Violet 139
White

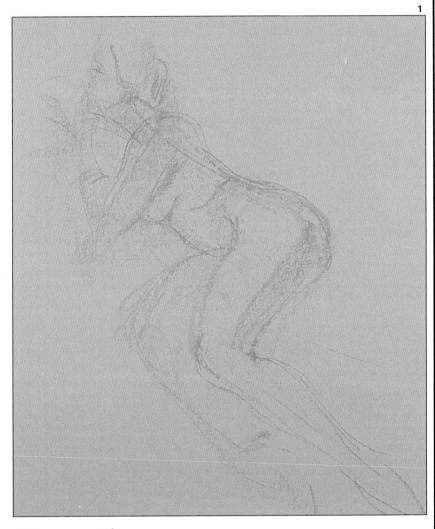

1 A warm, neutral-coloured support is chosen, and orange used for the initial line drawing. Violet is used for areas of shadow and dark outline.

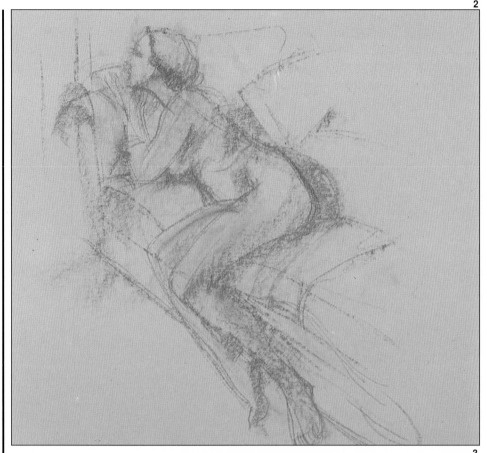

2 Further areas of shadow are laid down in orange and violet. The sofa is drawn in and given form so that the model does not appear to be floating in mid air.

3 To create a clear but delicate line of shading, excess pigment is rubbed away with an eraser. This also has the effect of very softly blending the colour.

4 A little green undercolour is applied to the areas of shadow to cool the tone. This technique is useful whenever painting flesh tones because it also adds depth. The artist also starts to work on the model's head, shoulder and arm. The painting is given a light spray with fixative which will slightly darken the tones.

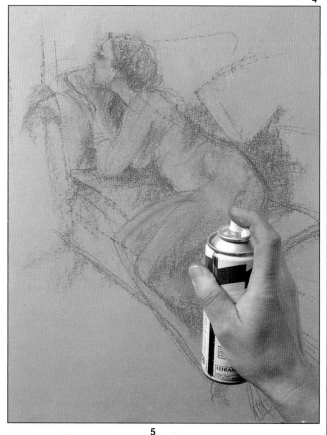

4

5

5 Areas of shadow are again outlined in broad bands of orange, emphasized by the red shading of the sofa, and white highlights are added to areas with light shining on them.

6 This close-up photograph shows how the artist adds layer upon layer of colour with the side of the pastel to build up soft flesh tone. Here orange is layered on to green, and under both colours is a layer of red.

7 By using his finger to blend the colours into brown the artist achieves more control over the tones he is mixing.

6

7

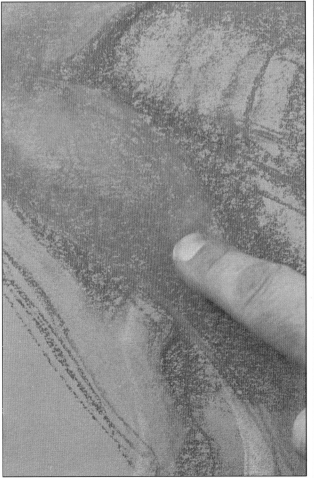

8

8 Here you can see how the soft layers and bands are blended to give the skin an almost luminous quality and build up form. The legs are highlighted in white and pink.

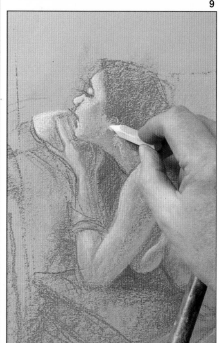

9

9 White pastel is laid down over the face which is in full light.

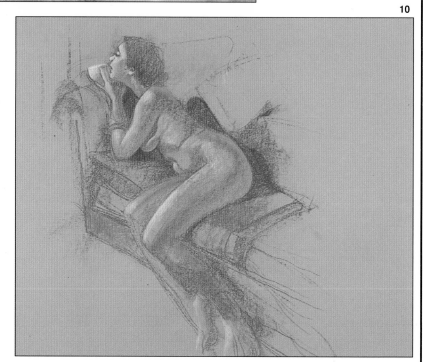

10

10 The highlights on the face are toned down with pink. The areas of the upper body and upper legs are well defined with shading.

11 Layers of colours are mixed to give soft flesh tones and rich, shiny texture for the hair. The cheek bones are gently shaded, and soft warm shadow is added under the chin to accentuate the jaw line.

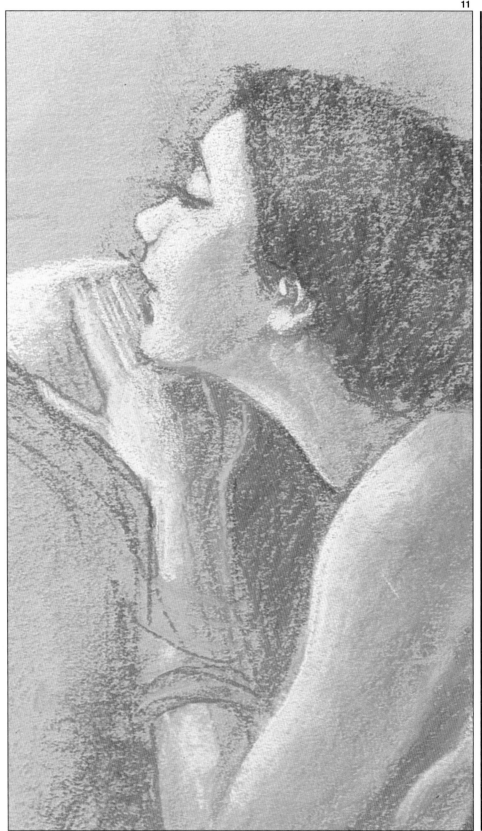

FEMALE FIGURE

12 The tones on the face and fingers are blended in. The artist applies violet highlights to the hair, and rests his arm on a maulstick so that he will not smudge other parts of the painting.

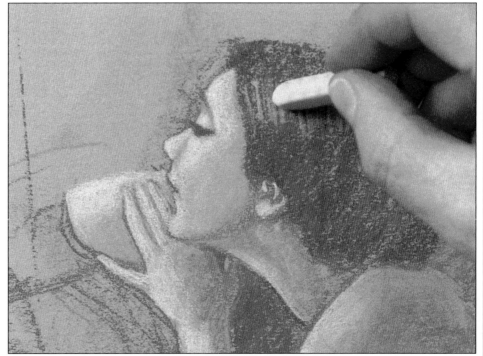

13 Details of the feet are now added in. The sole of the right foot is shaded and outlined with green to add coolness to the tones, and the left foot is highlighted in white. The toe joints and toenails are clearly defined by using the side of the pastel.

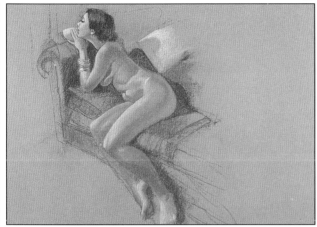

14

14 Green shadow is worked into the sofa, and highlights onto the wall.

15 In the finished painting the shading on the sofa is blended and completed. Its heavy texture provides an ideal contrast to the soft, warm skin tones of the model.

15

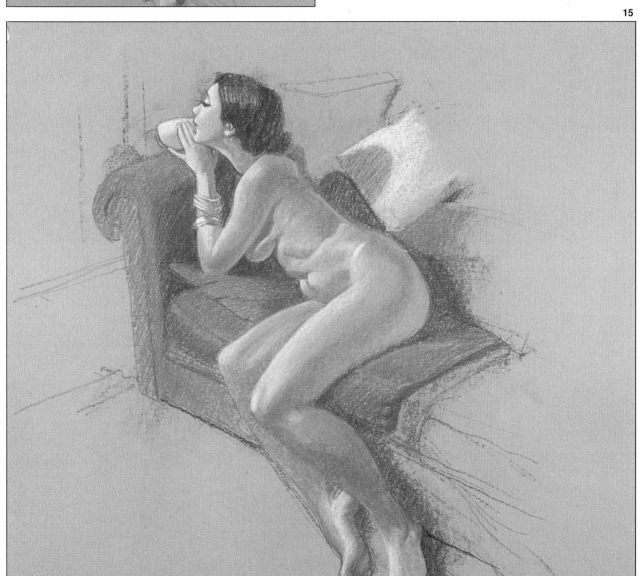

Index

Acknowledgements

The author would like to thank Ian Sidaway, Roy Ellsworth and John Melville for their help during the writing of this book.

Credits
The artwork and demonstrations were done by Ian Sidaway and Roy Ellsworth.
Special thanks are due to Rowneys and The London Graphic Centre for supplying the art materials.

Studio and step-by-step photography by John Melville. Other photographs are reproduced by permission of the following: Paul Barnett, Architectual Association p. 96; The Bridgeman Art Library Ltd pp. 8—9, 10, 11, 12, 13 (top), 14 (bottom), 15 (bottom); Tate Gallery pp. 13 (bottom), 14 (top), 15 (top).